CAMBRIDGE INTRODUCTION TO THE HISTORY OF ART

The Seventeenth Century

Other titles in the series

1 THE ART OF GREECE AND ROME *Susan Woodford*
2 THE MIDDLE AGES *Anne Shaver-Crandell*
3 THE RENAISSANCE *Rosa Maria Letts*
5 THE EIGHTEENTH CENTURY *Stephen Jones*
6 THE NINETEENTH CENTURY *Donald Reynolds*
7 THE TWENTIETH CENTURY *Rosemary Lambert*

Frontispiece
Gianlorenzo Bernini, *The Ecstasy of St Theresa*,
1645–52, marble, lifesize, Cornaro Chapel,
S. Maria della Vittoria, Rome.

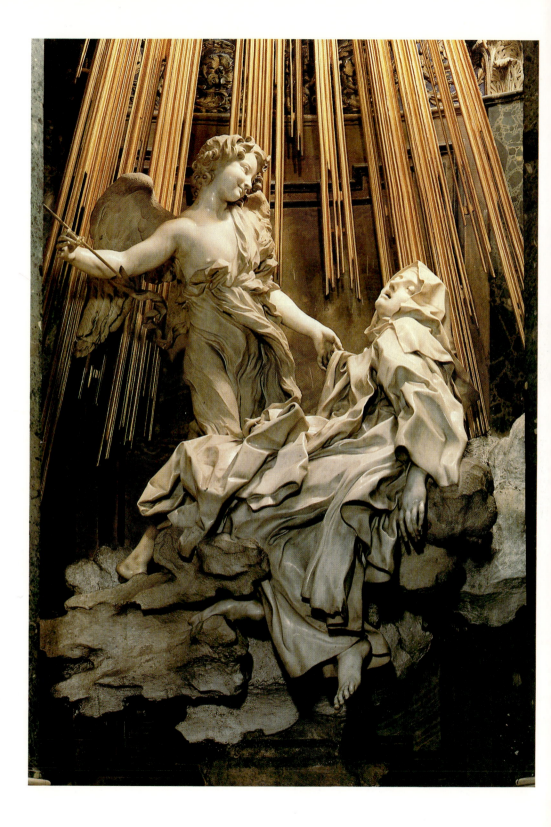

The Seventeenth Century

MADELEINE & ROWLAND
MAINSTONE

CAMBRIDGE UNIVERSITY PRESS
Cambridge
London New York New Rochelle
Melbourne Sydney

To Robert, Anita and Marion

Published by the Press Syndicate of the University of Cambridge
The Pitt Building, Trumpington Street, Cambridge CB2 1RP
32 East 57th Street, New York, NY 10022, USA
296 Beaconsfield Parade, Middle Park, Melbourne 3206, Australia

© Cambridge University Press 1981

First published 1981

Printed in Great Britain by Balding and Mansell, Wisbech

British Library cataloguing in publication data
Mainstone, Madeleine
The seventeenth century. – (Cambridge introduction to the history of art).
1. Art, European 2. Art, Modern – 17th century – Europe
I. Title II. Mainstone, Rowland III. Series
709'.03'2 N6756 80-40039
ISBN 0 521 22162 5 hard covers
ISBN 0 521 29376 6 paperback

Acknowledgements
For permission to reproduce illustrations the author and publisher wish
to thank the institutions mentioned in the captions. The following are
also gratefully acknowledged:
cover, pp 38, 63 (right) Ampliaciones y Reproducciones MAS;
frontispiece, pp 19, 23, 83 Fotografie della Societa Scala, Florence; pp 2,
4, 5, 7 (left), 9, 11, 13, 14 (left), 16, 17 (bottom), 49, 55 (right), 76, 77, 79,
80, 84 The Mansell Collection; p 15 Giraudon; pp 22, 25, 29, 39, 44, 46,
55 (left), 69 (below), 73 (top) reproduced by courtesy of the Trustees,
The National Gallery, London; p 28 reproduced by permission of the
Trustees of the British Museum, London; pp 30, 34, 40, 50, 60 (top left),
69 (top) Cliché des Musées Nationaux, Paris; p 32 Bildarchiv foto
Marburg; p 39 photograph Cooper-Bridgeman Library; pp 53 (left), 66
reproduced by permission of the Trustees of the Wallace Collection;
p 63 (left) Greater London Council, The Iveagh Bequest, Kenwood;
p 74 Reproduced by gracious permission of Her Majesty the Queen; p 78
Lauros-Giraudon; p 82 (left) from Borromini, *Opera*, 1702/25; p 82
(right) from Guarini, *Architettura Civile*, 1736; pp. 86 (above), 88 (right)
photograph Rowland Mainstone; p 86 (below) from Poley, *St Pauls
Cathedral*, 1927.

Contents

PREFACE vii

1 INTRODUCTION 1
Early seventeenth-century Rome: the Church triumphant 1
From Renaissance to Baroque art: painting 3
Sculpture and architecture 7

2 SCULPTURE: DYNAMIC MOVEMENT AND SENSUOUS FLESH
RENDERED IN MARBLE 13
Mythological groups 13
Papal tombs 15
Portrait busts 17
The baldacchino of St Peter's and the chair of St Peter 18

3 PAINTING: REALITY DRAMATISED THROUGH LIGHT 21
Caravaggio 21
Caravaggio's followers in Flanders and Holland 24
Rembrandt's religious works 26

4 PAINTING: FLEMISH COLOUR AND EXUBERANCE 33
Rubens and Italian art 33
Rubens' religious works 35
Optimism pervades everything 37
Colour in Flemish and Dutch flower paintings 40

5 PAINTING: PASSION CHECKED BY REASON 43
Annibale Carracci and his followers 43
Poussin 46
Art at the court of Louis XIV 48

Contents

6 PAINTING: BAROQUE PORTRAITS 51
Court portraits of Rubens and van Dyck 52
French court portraits 55
Group portraits of the Dutch burghers 56
Rembrandt's revelations of the human soul 58
Velazquez 63

7 PAINTING: LANDSCAPES, TOWNSCAPES AND INTERIORS 65
Flemish landscapes: Rubens' grand sweep 66
Dutch landscapes: the look of the land 67
Classical landscapes: the Roman Campagna 69
Dutch townscape: Vermeer's Delft 71
Dutch interiors 72

8 ARCHITECTURE AND THE UNIFICATION OF THE ARTS 75
The grand design 75
Roman church façades 79
New ways of shaping space 81
Reaching for heaven in ceiling paintings 83
Baroque architecture outside Italy 85

NOTES ON ARTISTS 89
FURTHER READING 92
GLOSSARY 93
INDEX 95

Preface

To anyone who likes to use their eyes, the art of the seventeenth century has much to offer. Great masterpieces of painting, sculpture, and architecture were produced. The artists were superb story-tellers and very skilful at arousing emotions, suggesting character, or conveying a mood. Different artists told the same story in different ways or saw different things in the people whose portraits they painted or the landscapes they knew. But they all spoke very directly to those who would see their work, so that we can often read it almost as we would read a book.

Perhaps the best approach, if we are coming to this art for the first time, is to allow it to speak directly to us in this way. The illustrations in this book have been carefully selected to allow us to do just that, as far as is possible without standing in front of the painting or sculpture or building itself. Of course we should also take every chance we get to see the originals. In front of a painting we can try to figure out what the subject is, what the people in it are doing, why they are there at all. In front of or inside a building we can ask what effect it has on us and why. Just doing this – even with the help of the illustrations here – can be interesting and will allow us to judge how far the work still 'speaks' directly to us after three hundred or more years.

Reading a work of art is, however, not very different from read-ing a book – or a poem. It is an art at which we become better with practice and which becomes easier when we know something of the 'language' and of the artist's intentions. The text of this book has been written to help us to acquire this art. It tells something about the background against which the artists worked, about what they were asked to do, and about what they themselves were trying to do. We also see how they achieved some of their effects and learn to identify the particular qualities of different works.

Each chapter explores a theme that was important in the art of the century – themes like its development from the art of the previous

century; the search for dramatic realism; colour and movement; the more restrained approach favoured by other artists; the portraits that give us an unrivalled insight into the characters and pretensions of people of the time; and different attitudes to the landscape and the surroundings of everyday life. After looking at the illustrations we can, if we like, go straight to those themes that interest us most – or even to the discussions of individual works – before reading the book as a whole to gain a more balanced idea of the achievements of the century. Explanations of terms that may be unfamiliar and further notes on the principal artists mentioned will be found at the end.

The book is intended only as an introduction, so some suggestions for further reading are made at the end. It was Madeleine Mainstone's hope, in writing it, to share with her readers – as she had so successfully shared with those to whom she lectured while Keeper of Education at the Victoria and Albert Museum – her own enthusiasm and deep love for the great art of this century. Unfortunately she was already a victim of cancer when she began the book. She died without being able to finish it, but not before she had written many marvellous and moving descriptions of individual paintings and pieces of sculpture – many of the descriptions in chapters 2 and 3, and most of those in chapters 4 to 7. It has fallen to me to fill in the main gaps, to sketch in backgrounds, and to write the concluding chapter and most of the introduction. This I have tried to do in the same spirit, as one of the last tributes I can make to her who shared her life with me for so long and to whom I owe so much in so many ways. Two other people must be mentioned – Anne Boyd of the Cambridge University Press, whose idea this series of books was and Patricia Hurford, a personal friend. I am sure that Madeleine would wish me to thank them on her behalf for their continued encouragement and help at a difficult time. To her thanks I should like to add my own for their further encouragement, without which I should have been reluctant to accept that mine should be the *summa manus*.

ROWLAND MAINSTONE
St Albans, April 1980

1 Introduction

The seventeenth century saw a marvellous upsurge of artistic activity. It was the age of giants like Bernini and Rubens, Claude and Poussin, Rembrandt and Velazquez, and of many other masters of almost equal stature even if they are less well known today. It was also a confident and optimistic age, at least in those centres that were most productive. There were patrons and artists who could think and act on a grand scale. And there was little of the fear that we sometimes have today of appealing directly to the emotions of the viewer.

To the art of this period we now normally give the name Baroque. That art was not all-of-a-piece. Each great master had his own style. Such individual differences in style were reflected in broader differences between the arts of different countries – between, for instance, the art of Rome in the early part of the century and the later art of France or Holland. But artists in France and Holland and elsewhere kept in touch with those in Rome, and they all shared a keen interest in the art of the Renaissance and in that of ancient Rome. This meant that there were also important similarities.

Baroque art began in Rome, just as Renaissance art had begun in Florence. It began in the service of the Catholic Church and of wealthy princes of the Church. When we have seen how this came about, we can compare some of the works of art themselves with earlier works. This will give a first idea of some of the most typical characteristics of the art. Later in the book we shall see something of the differences of style that developed during the century.

EARLY SEVENTEENTH-CENTURY ROME: THE CHURCH
TRIUMPHANT

In the years immediately after 1527 few can have seen any real prospect of Rome becoming again the artistic capital of the Western

world or of the Catholic Church and the papacy being largely responsible for this revival. In 1527 the city had been sacked by a large army of Spanish mercenaries at a time when the Church was already under strong attack from reformers like Luther. There was great destruction and many of the inhabitants who had escaped death but lost their homes went elsewhere. Yet, for those who stayed, the need to rebuild and restore the economy seems to have provided the same sort of spur to action as we have seen in countries devastated by more recent wars.

The Church fought back by reforming itself. Some of the initiative was taken by saintly and highly competent individuals – like St Ignatius who founded the influential missionary and teaching Society of Jesus (commonly known as the Jesuits), St Francis Xavier who was an early member of the Society and a missionary in the east, St Philip Neri who founded the Oratorians, and St Theresa who reformed the Carmelite Order. In 1542 Pope Paul III summoned a council of the whole Church. This Council of Trent, after sitting intermittently over almost twenty years, reaffirmed and clarified all the basic Catholic beliefs and tightened and codified the practices of the Church. There was to be no compromise with the Protestant Lutherans, Calvinists, and others like them.

Michelangelo Buonarroti, detail of Christ from *The Last Judgement*, 1536–41, fresco, Sistine Chapel, Rome.

The mood of confident defiance that animated the council was better expressed by the majestic Christ of Michelangelo's *Last Judgement*, completed shortly before it opened, than by any work of painting or sculpture of the later part of the sixteenth century. This was not because the council had been iconoclastic as had some of the Protestants. It had not sought, as they had, to banish paintings or statues of Christ or the saints from churches. It had, on the contrary, approved such representations for the instruction of the faithful. But the emphasis was initially on buildings.

Work continued on the rebuilding of the old basilica of St Peter's, the dome being completed in 1590. Large new churches were built for, among others, the Jesuits and the Oratorians. And, towards the end of the century under Pope Sixtus V, the city itself was replanned as we see it today – with long straight streets connecting focal points adjacent to important churches. Each focal point was marked by a fountain or an antique obelisk. It was the declared aim of Sixtus V to make the city once more a worthy capital, a worthy Christian

successor to pagan Imperial Rome. To help achieve it, surviving ancient monuments were freely plundered or adapted.

By the early seventeenth century there was no more need for defiance. The Church had triumphed and there were now plentiful commissions for new altarpieces and many other kinds of work. This made Rome a magnet for leading artists from the whole of Italy and from the Low Countries, France, and Spain as well. Much of their work had a deeply religious content, whether it reinterpreted old themes or explored new ones such as the lives of some of the reforming saints mentioned above – men and women who had died only recently and who continued to inspire many. Indeed many of the artists were themselves deeply religious men. But there were also commissions for non-religious works for the decoration of palaces and villas. Neither the artists nor their patrons seem to have felt any inconsistency between their Christian faith and a delight in all that life had to offer. So they were not afraid to turn also to the rich legacy of pagan myths that had been passed on by the humanists of the Renaissance.

FROM RENAISSANCE TO BAROQUE ART: PAINTING

These pagan myths – stories of the gods of ancient Greece and Rome – had often been chosen as subjects for paintings, sculpture, or for palace decorations in the later decades of the Renaissance. One such decorative scheme was that carried out by Raphael and his assistants in the suburban villa of a rich banker, Agostino Chigi, in 1516. There, in a room opening to the garden, the *Marriage Feast of Cupid and Psyche* was painted on the flat centre of the ceiling as if on a tapestry stretched as a temporary awning beneath an open sky.

In 1595 this villa, now known as the Villa Farnesina, had passed into the hands of the young Cardinal Oduardo Farnese. The cardinal had also inherited the family palace on the other side of the Tiber, the Palazzo Farnese, and its superb collection of marble statues found among the ruins of ancient Rome. He asked Annibale Carracci, a painter from Bologna, to decorate the ceiling of the large dining room of this palace with what might be regarded as an early

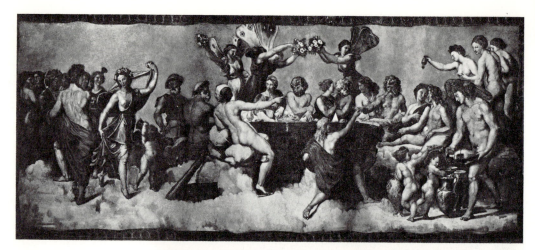

above
Raphael, *Marriage Feast of Cupid and Psyche*, 1516, fresco, Villa Farnesina, Rome.

right
Gallery of the Palazzo Farnese, Rome, showing Annibale Carracci's ceiling fresco.

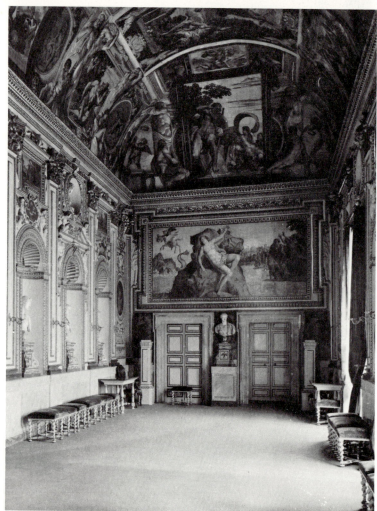

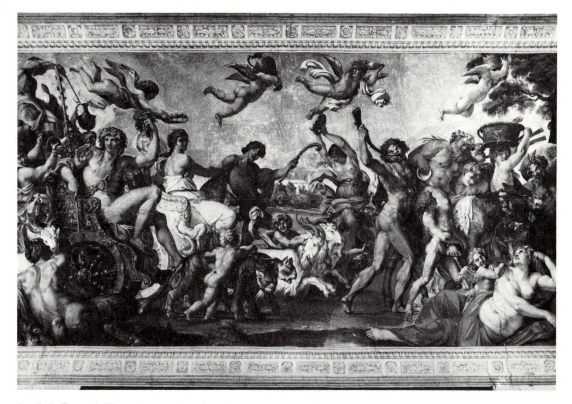

Annibale Carracci, *The Triumph of Bacchus and Ariadne*, 1597–1600, detail from ceiling fresco, Palazzo Farnese, Rome.

Baroque counterpart to Raphael's decoration – with scenes from the lives of the gods as described by Ovid.

Annibale, with a larger surface to cover, adopted a more complex scheme than Raphael's. He imagined that, instead of the actual ceiling, there was a balustrade above the cornice, and that the space of the room opened out further above this balustrade with glimpses, even, of the open sky. His painted sky can be seen in each corner. Elsewhere the real architecture of the room is shown as continuing upwards to support a second higher cornice that is only partly visible. This imaginary upward continuation is richly decorated with carved figures and bronze roundels, all rendered in paint and made more convincing by nude youths painted in true flesh colours as if they were sitting or comfortably kneeling on the true cornice in front of the balustrade. The main scenes of the lives of the gods were set within this architectural framework as if they were framed pictures.

The picture in the centre of the ceiling shows Bacchus and Ariadne triumphantly riding in a chariot drawn by leopards and

5

goats and preceded by a fat drunken Silenus sitting on an ass. He is supported by happy naked youths making music and dancing tipsily. A satyr and a maenad recline in the lower corners and enhance the feeling of depth as the sunlit procession moves forward against a natural landscape. The overall mood is an exuberant gaiety.

This gaiety, the sense of depth that is conveyed, the realism of the painting, and the sense of movement are some of the characteristics that were to become typical of much Baroque painting. None of them is present to the same extent in Raphael's ceiling. Notice, for instance, the relatively static poses of Raphael's figures and the way in which they are lined up before us almost as a flat frieze. We cannot, however, credit Annibale alone with all these innovations. They had also appeared by this time in Venetian painting, which Annibale knew well.

To do justice to the Venetians, we can compare two religious paintings – a large altarpiece, *The Assumption of the Virgin*, painted by Titian in 1516–18 for the Frari Church in Venice, and another of the same subject painted by Annibale's brother Agostino in about 1592.

If we set aside the fact that Titian shows us rather more, with God the Father waiting at the top to receive the Virgin and an angel beside Him holding a crown to be placed on the Virgin's head, what differences in character are there? Most obviously, perhaps, there is a greater unity between the elements of Agostino's picture. There is a more continuous flow of movement between the figures, just as there is in Annibale's *Bacchus and Ariadne*. But there is also a stronger contrast between the figures, a contrast which makes a strong impact and arouses our emotions. We may say that Agostino's picture is more dramatic, so that we feel more readily drawn into the action. These also were to become common characteristics of Baroque art. We must however beware of saying that Agostino's is therefore the better picture. In the arts, gain in one direction often means loss in another, and we may today find Titian's version the more profound and ultimately the more moving. This is partly a matter of our own temperament and partly a matter of the two artists' abilities to achieve what they set out to do. What is important to us here is that it was Agostino's approach that better satisfied the

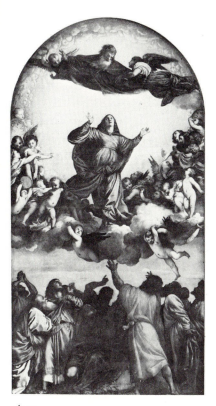

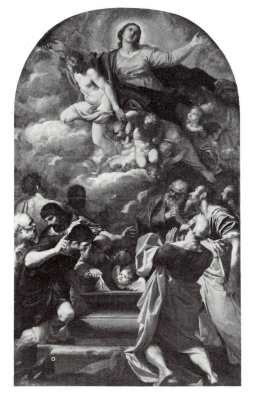

temperaments of the Catholic faithful of the seventeenth century. In other respects, such as the realism of treatment of the individual figures and the use of colour, there is less difference between the two versions. Here Agostino had learnt from Titian as Rubens, in particular, was to do later.

SCULPTURE AND ARCHITECTURE

These Baroque characteristics can also be seen to a large extent in sculpture and architecture. Naturally they are not seen in quite the same way and they did not appear so clearly until a little later. The three artists in whose work they then appeared – Bernini, Borromini, and Pietro da Cortona – were not even born until the closing years of the sixteenth century, and architecture has always been an art in which change takes longer to achieve because of the time it takes to build.

Direct comparisons can now be made not only with Renaissance

art, but also with the sculpture and architecture of ancient Rome and, to a lesser extent, of ancient Greece – with what is known as classical art. Little remained of classical painting. But much did remain, and much still remains, of the sculpture and buildings of ancient Rome, and the sculpture included numerous copies of earlier Greek works. These remains served as both a model and a challenge to seventeenth-century artists, as they had done to the artists of the Renaissance, though seventeenth-century artists looked at them differently and were most excited by different examples. We can see this well if we compare the marble figures of the Old Testament David carved by Michelangelo at the beginning of the sixteenth century and by Bernini more than a hundred years later.

Michelangelo certainly studied and drew classical sculptures as well as live models in his own studio. His *David* is a typical Renaissance work. It is clearly related to the so-called *Apollo Belvedere*, which had been discovered not many years previously and is probably a Roman copy of a Greek original of the fourth century BC. They have the same stance, with the weight on one leg and balanced by an S-shaped twist of the whole body. Michelangelo's *David* has a greater sense of energy than the *Apollo*. Nothing is frozen. Every muscle is alive beneath the skin. We feel that movement is only briefly stilled before the hurling of the stone that will kill Goliath. But stilled it is in both statues. And there is a similar stilling of movement in the imperious gesture of the later Christ of the *Last Judgement*.

Bernini shows David in the very act of hurling the stone. Even the tightly clenched lips tell of the intense concentration and effort of this moment. Though there is no surviving Classical sculpture that has quite this expressiveness, the so-called *Borghese Warrior* of the second or first century BC is now a closer parallel than the *Apollo*. Notice also that, if we stand in front of Bernini's *David* (as one originally had to since it was set against a wall), we not only see the action but are caught up in it. The stone will soon shoot past us; we may even feel that we are Goliath. Small details – like the curling of the toes of the right foot over the edge of the plinth to gain a better grip – add to our sense of immediacy and of participation in the action. In comparison, Michelangelo's *David* is a completely self-contained work.

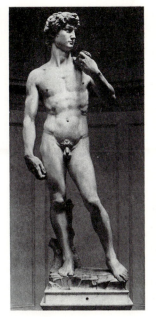

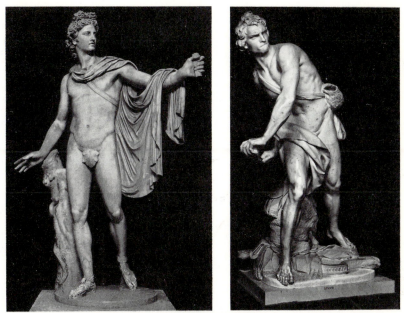

When, later, he sculpted *The Ecstasy of St Theresa* for a chapel
in the Roman church of S. Maria della Vittoria, Bernini sought
by rather similar means to awaken a more religious emotion. St
Ignatius had set great store on the value, to a Christian, of reliving
the emotional experiences of Christ's passion, resurrection and
ascension, and of meditating on the torments of hell and the happi-
ness of communion with God. Bernini, like many others at this time,
followed the spiritual exercises prescribed by St Ignatius. The St
Theresa group is intended to help the person kneeling at the altar
below it to enter into the mystical experience of the saint. According
to her own account an angel visited her armed with a golden spear
tipped with flame. He plunged the spear several times into her heart,
causing intense pain but also leaving her consumed by the love of
God. Again Bernini gives us a momentary glimpse – a glimpse of the
moment when the angel holds the spear poised for another thrust.
But what he really shows us is a vision of the event. He has created
this vision before our eyes as we kneel in the chapel. In fact the
sculptured group of saint and angel is only part of the total vision.
The saint, in polished white marble, swoons back on a darker
coloured cloud while gilded rays of divine illumination stream down
from above, lit by a hidden window. In the vault above, the heavens
open to reveal more angels. And our sense of the reality of the vision
is increased by the way in which its architectural frame breaks

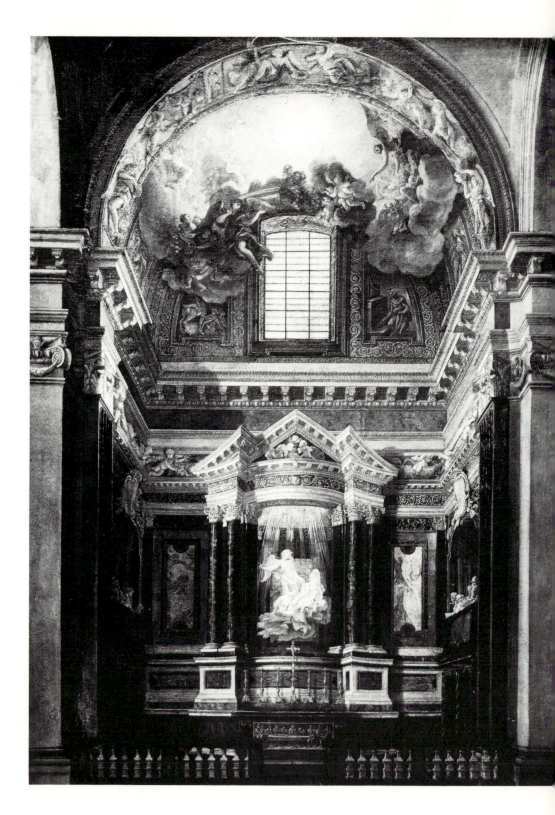

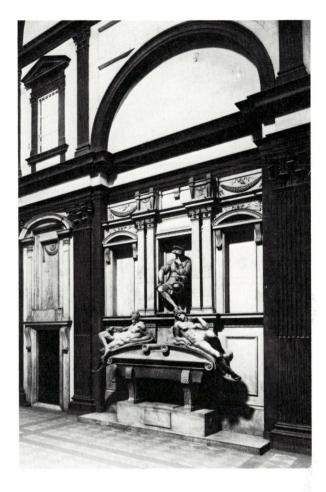

forward towards us and by the presence of the sculptured figures of other worshippers whom we notice in balconies at each side of the shallow chapel.

It would be a great exaggeration to describe the chapel itself as typical of Baroque architecture; no single work can be that, and certainly not a small chapel whose simple rectangular plan was a legacy from an earlier period. But if we compare it with Michelangelo's New Sacristy in the church of S. Lorenzo in Florence – also the work of a single artist containing major pieces of his sculpture – we can see some of the characteristics that distinguished Roman Baroque architecture from even a highly original work of the later Renaissance. The New Sacristy is self-contained, like Michelangelo's sculpture. We feel almost like intruders within it. And, though it provides a perfect setting for the sculpture, it would not be difficult to separate sculpture and architecture. In Bernini's

chapel, sculpture, painting, and architecture merge together and become one; and, far from making us feel intruders, they draw us in. We might, in this sense, say that Roman Baroque architecture is dynamic like Bernini's *David*, whereas Renaissance architecture is static, even if taut and powerful like Michelangelo's *David*.

We might also say that in *The Ecstasy of St Theresa* sculpture takes on some of the quality of painting. The group is set so that it can be seen only from the front within its architectural frame, and the controlled lighting from the hidden window enhances the impression of colour given by the gilding and the use of coloured marble. Equally the painted angels and clouds in the vault above take on some of the quality of sculpture through the illusion they create of three-dimensional form.

This blurring of distinctions between the arts was seen also in Annibale Carracci's illusionistic upward continuation of the real architecture of the room in his ceiling painting in the Palazzo Farnese. And we shall see it again in another way when we look at Bernini's two most important contributions to the interior of the new St Peter's – the baldacchino under the dome and the chair of St Peter in the apse (pages 18 and 19).

In the main, however, sculptors, painters, and architects work with different means. The sculptor and the painter may wish to convey similar illusions of reality, but, where the sculptor can create real three-dimensional forms to be seen in real light, the painter can only suggest them by using colour on a flat surface. It is usually only the architect who creates spaces through which we can actually move.

We shall, therefore, look separately at the three arts, looking first at sculpture, then giving more space to painting, and turning last to architecture in which painting and sculpture often played an important part. We shall see something of the different ways in which the arts developed in different countries, but we shall concentrate on different themes – from mythological and religious subjects to portraits and landscapes – and on different approaches to them.

2 Sculpture: dynamic movement and sensuous flesh rendered in marble

Gianlorenzo Bernini was the leading sculptor of the century – some even regarded him as the greatest artist, for, like Michelangelo, he was also painter, architect, and more besides. He overshadowed his contemporaries both by his skill and by the magnitude of his output. Indeed he was able to fulfil the larger commissions he received from successive popes only by using some of his slightly less skilful contemporaries as assistants in his workshop. He would provide the ideas, developed in sketches, small clay models, and larger plaster models. His assistants would then undertake much of the carving. Early works like the *David* were, however, his alone.

In this chapter we shall, therefore, concentrate on Bernini, though we shall draw comparisons with works by two of his Roman contemporaries and by the French sculptor François Girardon. We shall include Bernini's two major works for the new St Peter's – the baldacchino and the chair of St Peter – that are as much architecture as sculpture.

MYTHOLOGICAL GROUPS

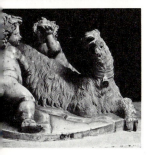

Gianlorenzo Bernini, *The Goat Amalthea with the Infant Jupiter and a Faun*, *c.*1615, marble, Borghese Gallery, Rome.

Like Michelangelo, Bernini closely studied and sketched the ancient sculpture collected in the Vatican, from the graceful *Apollo Belvedere* to the most violently dramatic work that has survived, the group of Laocoön and his sons struggling with snakes. These figures and groups displayed a remarkable knowledge of anatomy, understanding of the movement of bodies, diversity of composition, and naturalism in the treatment of the textures of skin, hair, fur, feathers, or clothing. As a boy he was so fascinated by them that his one desire was to emulate them. We can see this well in one of his earliest works to have survived, *The Goat Amalthea with the Infant Jupiter and a Faun*. It is said that he carved it as a humorous deception. So convincing was it that it was long mistaken for an ancient work.

right
Gianlorenzo Bernini, *Pluto and Persephone*, 1621–2, marble, lifesize, Borghese Gallery, Rome.

far right
Gianlorenzo Bernini, *Neptune and Triton*, 1620, marble, height 184 cm, Victoria and Albert Museum, London.

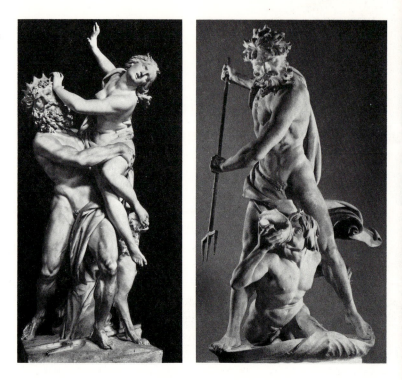

But Bernini was not satisfied with simply proving himself against the ancient sculptors. Just as Annibale Carracci had painted new, lively, natural scenes inspired by the old myths (p. 5), so Bernini sought to recreate episodes from them in dramatic and lifelike sculpture. Look how, in his *Pluto and Persephone*, the God of the Underworld, Pluto, picks up Persephone and carries her away to his dark abode while she cries and struggles and tries to push him away with her hand. She is powerless against her abductor, whose hands grab around her thigh and buttocks, his fingers finding a hold in the soft flesh. And this is marble! Yet their bodies are so real we want to touch them. Their skins are marvellously sensuous; the female soft and the male taut, with hair flying in the air and drapery fluttering in the rush of the movement. Pluto rushes forward and will have passed us before we can intercept him.

Like the *David*, this group was made for Cardinal Scipione Borghese and was designed to be set against a wall in his villa (now the Borghese Gallery). Though the twisting body and flying arms of Persephone have a three-dimensional freedom that must have taxed to the limits even Bernini's supreme skill in cutting, it is designed similarly to be seen from the front and to make an immediate impact.

The same was true also of another group made at this time –

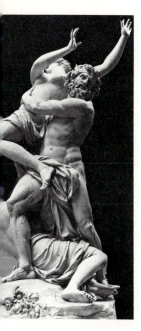

François Girardon, *Pluto and Persephone*, 1677–99, marble, lifesize, Versailles.

Neptune and Triton. This group was carved to be set over a fountain at the far side of an oval pond in the garden of the Villa Montalto. The life-size Neptune thrusts forward his bronze trident towards the water below while Triton rises and blows on his conch shell to still the storm that has been raised.

In these works, and others like them, we see very well the buoyant self-confident mood of the early seventeenth century. In another interpretation of the Pluto and Persephone story by the French sculptor Girardon we see the more restrained mood typical of French art – particularly painting – later in the century. Girardon's group is also a highly accomplished work, beautifully composed and carved with great technical skill. But we may ask ourselves whether the figures are as natural looking and healthy as Bernini's; whether Persephone struggles as convincingly; whether the drapery and the hair express anything; and whether we feel similarly involved in what is taking place. Here the dramatic emotion conveyed by Bernini has been supressed for the sake of decorum or good taste and there seems, as a result, to have been a loss of conviction. This trend towards restraint will be discussed further in chapter 5.

PAPAL TOMBS

Bernini's chief contemporary and rival in Rome was Alessandro Algardi. Their work can be directly compared in two papal tombs in St Peter's. Bernini's tomb of Urban VIII was begun in 1627 and much of the work was done during the pope's reign. Algardi's tomb of Leo XI was begun in 1634 long after that pope's death. Both tombs took about twenty years to complete so that work on them proceeded largely in parallel. There had already been tombs in which a seated pope was flanked lower down by two allegorical figures (figures denoting appropriate virtues), but these tombs are different in that the two figures are standing upright close to the pope and the actual sarcophagus (or coffin) is treated as part of the monument.

In both cases the seated pope seems vigorously alive with the heavy mantle drawn up over his left knee, the soft linen of the robe falling in tiny rippling rhythms underneath it. The pope is looking

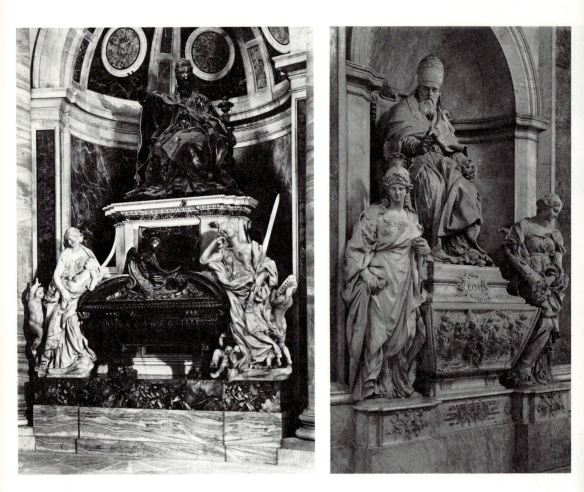

above
Gianlorenzo Bernini, tomb
of Urban VIII, 1627–47,
marble, St Peter's, Rome.

above right
Alessandro Algardi, tomb
of Leo XI, 1634–52,
marble, St Peter's, Rome.

down and blessing us with his right hand. Active, natural and very human, although powerful in his commanding position, the pope appears as he often did in everyday life, and as the pope can still be seen when he is carried into St Peter's on feast-days. The difference between the two monuments lies in the calm, almost restrained posture of Leo XI in Algardi's tomb, with its design based on horizontals and verticals, and the much more animated attitude of Bernini's Urban VIII planned on a diagonal, which swoops forward. Bernini used different materials, dark bronze for the pope, white marble for Charity and Faith, coloured marble for the sarcophagus and pedestal, with coloured marble in the niche behind. This makes his monument far more 'pictorial' than Algardi's, whose works were on the whole more restrained.

above
Guiliano Finelli, *Francesco Bracciolini*, after 1633, marble bust, height 66 cm, Victoria and Albert Museum, London.

below
Gianlorenzo Bernini, marble busts: *Thomas Baker*, c. 1638, height 83 cm, Victoria and Albert Museum, London; (bottom) *Louis XIV*, 1665, height 80 cm, Versailles.

PORTRAIT BUSTS

A similar comparison can be made between the portrait busts of the poet and intellectual of Urban VIII's court, Francesco Bracciolini by Giuliano Finelli, and the English aristocrat Mr Baker by Bernini (and assistants). Finelli shows his sitter as secure in a tranquil existence whereas Bernini has chosen a transitory moment. For the Finelli bust we could use adjectives like static, detailed, finely textured, and for the Bernini, dynamic, broad, arrogant.

The bravura with which Bernini seems to endow his figures usually expressed the status or the character of the sitter, and often both. The great of this world are often people with a very strong character and flamboyant public image, able to take things as they come however sensitive they might be in private life. Bernini, like the painter Rubens (whom we shall encounter later), was attracted to such people, conversed with them, and knew them as friends.

His portrait of Louis XIV shows all this very well. In 1665 the King of France was twenty-seven years old and had been on the throne for five years. Whereas Thomas Baker looks rather dumb and silly, the arrogance of Louis is carried with authority. In both busts the mass of the thick hair with its highlights and deep shadows engulfs the smooth face, but the king's features are strongly reminiscent of a classical Apollo though enlivened by the very natural eyes. He turns his head on his shoulders as if something in the distance suddenly attracts his attention. His cloak is caught up by an imagined movement and forms a richly curved base with light rippling over the folds, offsetting the thick and rhythmic curls of long tumbling hair. The verticals of the upper arm in stiff metal armour, the mass of hair, the folds of the lace cravat, stabilise the curves and add to the sense of superiority which radiates from the face. Saint-Simon, a contemporary writer, described the king as having 'so natural and imposing a majesty that it appeared in his slightest gestures'. Bernini's imagination and intelligence captured the vanity of the king who ruled by divine right, accountable only to God. His daily encounters with the king during his stay in Paris enabled the sculptor to recreate in white marble the vibrant personality of this great ruler at the beginning of his fifty-five-year reign.

THE BALDACCHINO OF ST PETER'S AND THE CHAIR OF
ST PETER

Michelangelo's dome at St Peter's was meant to be the crowning
feature of a cross-shaped church with four equal arms. This was a
plan whose ideal symmetry made it particularly popular in the later
Renaissance. Inside, everything would have been naturally focussed
on the light-filled space under the dome where, beneath the new
floor, St Peter was buried.

Early in the seventeenth century, under Pope Paul V, the plan
was changed. The remaining part of the long nave of the original
Constantinian church was demolished and an even longer new nave
was built in its place by the architect Carlo Maderna. This provided
much more space for the pilgrims who flocked to the church on
special occasions, but to anyone entering the church through this
new nave or standing in it for a service the vastness of the space must
have been daunting. With nothing to mark or measure its extent,
and with the dome itself invisible from most positions, it must also
have been barely comprehensible. Something was needed to mark
the focal point of the tomb and the papal altar above it, to interrupt
the eye as it looked towards the far extremity of the choir, and to
provide a visual link between worshipper and the stupendous
architecture.

Soon after he ascended the papal throne Urban VIII, as part of a
programme for the embellishment and completion of the church
that continued throughout his long reign, commissioned Bernini to
make a canopy over the tomb and altar to meet this need. The bronze
baldacchino was the result. As a visual link with the architecture
above and around it, and with its four great twisted columns it is
really a work of architecture in its own right. But it is all made of
bronze with a richly decorated and highly sculptural form, and it is
partly this richness of decoration that makes it such an effective
visual link. Seen from well down the nave, the twisted columns and
the crown of four arms curving upwards and inwards to carry a
golden ball and cross echo, without tamely reflecting, the great
central piers and the dome above. They focus attention just as
effectively as the dome itself would have done in Michelangelo's
concept. Between the entablatures of the columns are gilt bronze

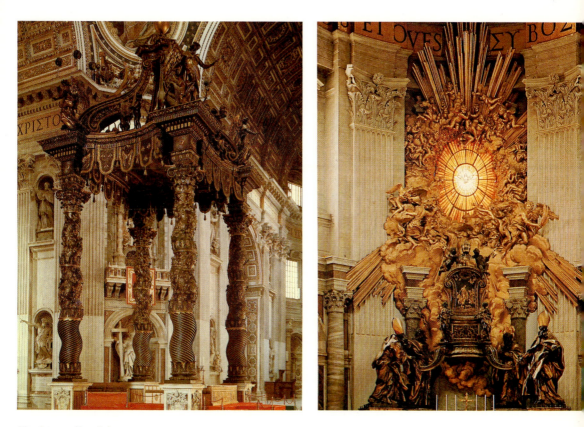

Gianlorenzo Bernini, baldacchino, 1624–33 (above), and chair of St Peter, 1657–66 (above right), St Peter's, Rome

hangings suggesting more directly the ceremonial canopies of silk and gold often used in the Middle Ages to indicate rank or importance. The twisted form of the columns themselves repeated, on a much greater scale, the form of the ancient marble columns that had stood in the same place beside the earlier shrine of St Peter in the Constantinian church. But their surface decoration was new – spiralling olive foliage among which may be discerned naked children at play and the bees that were the pope's insignia. This and other decoration becomes clearly visible only from close to. From an intermediate position it is possible to distinguish the four angels that stand on the columns as if about to take flight and, between them, other larger naked children displaying the papal regalia. Thus the whole structure becomes more and more alive as one approaches it, but without any loss to the immediate visual impact that it makes as first seen on entering the nave.

Originally it was intended that the shrine of the tomb and the papal altar surmounted and marked by the baldacchino should remain the one focus of the church and goal of the pilgrim. But later

it was decided to emphasise the long axis of nave and choir and provide a further goal at the end of the choir. This was to be a relic long associated with the saint – a chair he was believed to have used. Prominently displayed, it could symbolise his continuing presence presiding over all that happened in the church. Bernini was asked to devise a suitable means of display.

The chair was not very large and would have been too insignificant by itself in such a vast space. Ideally it should be visible between the columns of the baldacchino even from the end of the nave and should be fully disclosed as the final goal as one approached the baldacchino. Bernini's masterly solution was to encase the actual relic in a much larger chair of gilt bronze. This was mounted sufficiently high to be seen above the papal altar when viewed from the nave. It was flanked on the two sides by large figures of early doctors of the Church. They are linked to the chair by loops curving like those of the baldacchino crown, but do not appear to carry it. Golden clouds surround it, making it appear to float heavenward and giving almost the character of a vision, as in the case of the *Saint Theresa*. This character is suggested even more powerfully by Bernini's final stroke of genius – the painting of the dove of the Holy Spirit in the window above, surrounded by rays of golden light and throngs of angels.

Nothing could be more expressive of the Roman Baroque at its most magnificent, most expensive, and most fantastic and unreal, than these two works. Yet each is given the credibility of the possible by the natural movements of the figures, the unity of the whole conception, and the strength of the spiralling columns or the great burst of light above the chair.

3 Painting: reality dramatised through light

The realism at which many seventeenth-century artists aimed was partly a reaction against some of the highly mannered art of the second half of the previous century. This was an art in which a particular concept of good taste had favoured an exaggerated idealisation of the real world. The Carracci brothers, whom we met in the introduction, were among the first to go against this trend. But all art is in some sense an idealisation – if only a careful selection – from the untidy continuing flux of real life, with all its accidents and irrelevances. That is one thing that distinguishes it as art. Different artists reacted in different ways against the trend. The Carracci went back to and took inspiration from classical Greek and Roman sculpture and, in particular, its ideals of the human body. So, as we have seen, did Bernini. One near contemporary of the Carracci reacted much more violently and had a deep influence on later artists. He was Michelangelo da Caravaggio.

CARAVAGGIO

Caravaggio's revolution – for this is what it amounted to – was twofold. In the first place he rejected the classical ideals. When painting a scene from the life of Christ, for instance, he thought deeply about the ordinary folk, the fishermen and tax collectors, with whom Christ had actually associated. He put these people into his pictures and tried to make them seem real to the people of his own time. Secondly, to intensify the realism, he kept them in the foreground of the picture under strong light that concentrated all attention on what was taking place. Inessentials were obscured in dark shadow. He even showed some figures as if they were moving or gesturing out of the canvas towards the spectator. This was essentially the same means that Bernini used to involve the spectator in the action – though Caravaggio did it first and in paint, not marble.

In his *Supper at Emmaus*, Caravaggio painted the two disciples who had been joined on the road by an unrecognised stranger as very

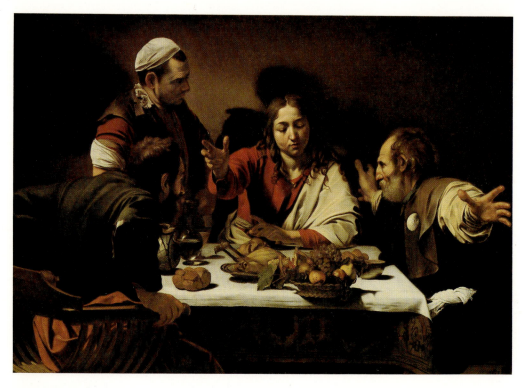

Michelangelo Merisi da
Caravaggio, *Supper at
Emmaus*, *c.* 1597, oil on
canvas, 139 × 195 cm,
National Gallery, London.

ordinary men with worn clothes and weatherbeaten faces. But he
chose to show the moment when, as they sat down with this stranger
to an evening meal, they recognised that he was indeed the risen
Christ. The disciples react in sudden surprise. In the picture one
man pushes back his chair in an impulsive response to what he sees,
and the other flings up his arms. There is something of the same
instantaneous reaction that Persephone showed when she pushed
herself away from Pluto. As onlookers, we are drawn into the drama.
The disciples' sudden movements seem to break out of the space of
the picture into our world; we are made partakers of the drama. The
realistic basket of fruit is precariously placed on the edge of the table
and might fall off at any minute. We want to stretch out a hand to
push it to safety and we notice that some of the fruit has burst open,
it is so ripe; and one of the apples has black marks on it. The strong
light picks out the figures against the dark wall in the background
and concentrates our attention on the drama of the sudden
recognition.

Another exciting picture by Caravaggio is one of a series of three
about the life of St Matthew. In *The Calling of St Matthew*, Christ
and an apostle approach from the right. Matthew, the tax collector,

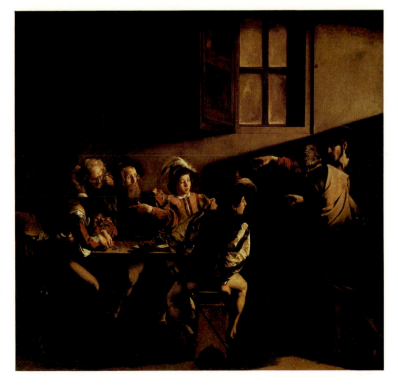

Michelangelo Merisi da Caravaggio, The Calling of St Matthew, c. 1598, oil on canvas, 338 × 348 cm, Contarelli Chapel, S. Luigi dei Francesi, Rome.

is at a table with friends. He is the only one who has understood fully that Christ is addressing him. The outstretched arm with the pointed finger seems a long way off, but the psychological current which flows from Christ to the tax collector is nearly tangible, it is so strong. Between the forward movement of the apostle and the counter movement of the dandy seated nearest and seen from behind, Christ's hand holds our attention – reminding us perhaps of the hand of Adam, about to receive life from God the Father, as painted by Michelangelo on the ceiling of the Sistine Chapel. Despite the vivid immediacy in the reaction of the figures around the table, the urgency of Christ's call issuing from the dignity of his figure dominates the atmosphere.

Again the sharp light, falling diagonally from outside the picture on the right, emphasises the expressions on the different faces and picks out only what is essential to set the scene and tell the story. The strong diagonal that it makes on the expanse of wall at the back reinforces the psychological current flowing from Christ's hand, both by the closely calculated placing of the diagonal and by the suggestion of light overcoming spiritual darkness. Notice also how closely calculated are the placing of the verticals and horizontals of

23

the window, the table, and the stool, and the secondary diagonals of the dandy's sword and the right leg of the seated man at the end of the table – both directed towards Matthew's own pointing finger. On the other hand, the precise setting remains ambiguous. It is not even quite clear whether it is indoors (as has usually been assumed) or outdoors (as seems more likely). It is perhaps closest to a shallow stage set. What Caravaggio shows us here is a highly organised and psychologically loaded almost theatrical reality rather than the chaotic reality of actual life.

Caravaggio's contemporaries reacted strongly to his paintings. Catholics who were seeking, under the guidance of priests like Philip Neri, for a new immediacy in their meditation on the Gospels, welcomed Caravaggio's truthfulness. His paintings stimulated their faith. Others, no less devout, found the paintings shocking or vulgar. There is always this problem with the realistic portrayal of familiar stories. The artist has to commit himself to precise details and this is bound to provoke disagreement. (Something of the same thing happens when Shakespeare is performed in modern dress.) Some of Caravaggio's patrons refused to accept the pictures they had commissioned for altars because the holy figures were represented as ordinary, even disreputable, people.

Caravaggio was a natural rebel and bohemian. His life was stormy. He was exiled from Rome after stabbing a man in a quarrel, and found refuge in Malta for some years. Pursued and attacked by his enemies, he died on a beach north of Rome when still only thirty-seven. He had never founded a school like the Carracci or passed on his ideas to numerous assistants as Bernini was to do later. But his paintings themselves nevertheless had a wide influence, particularly outside Italy.

CARAVAGGIO'S FOLLOWERS IN FLANDERS AND HOLLAND

Artists in the Low Countries had been painting ordinary folk at village weddings and as shepherds in Nativity scenes long before Caravaggio introduced them into his religious paintings in Italy. It is hardly surprising therefore that these paintings influenced artists in both Catholic Flanders and Protestant Holland when travel became easier with growing foreign trade and a twelve-year truce in the war with Spain.

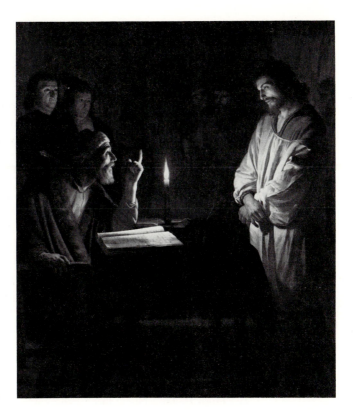

Gerard van Honthorst,
*Christ before the High
Priest*, *c.* 1617, oil on
canvas, 272 × 183 cm,
National Gallery, London.

Gerard van Honthorst, a painter from Utrecht, was in Italy from
1610 to 1620. His picture *Christ before the High Priest* was obviously
related to Caravaggio's religious works. The two main figures are
placed close to the observer and the only light comes from the candle
on the table leaving most of the canvas very dark and the bystanders
only dimly lit. This night scene with its chiaroscuro effect of light
and dark heightens the drama of the event where the High Priest
interrogates Christ who does not answer. The older man with the
weathered face and the admonishing finger makes a rather ineffec-
tive attempt to engage Christ in a dialogue. The contrast between
the two figures – the motionless standing Christ with wrists bound
and the seated priest in the middle of his argument – is sharpened by
the contrasts within each figure caused by the interplay of light and
shade. Christ's white overshirt with its vertical folds draws our
attention to his bound wrists and to his calm yet troubled face seen in
profile. The vertical of the candle separates him from the High
Priest, whose profile forms the counterpart to Christ's. Despite
these contrasts the scene is tense because the circle of light draws the
contrasting figures together. The drama is deeply human and

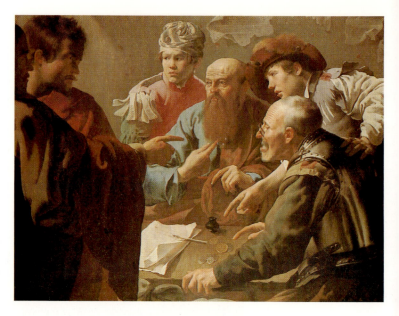

Hendrick Terbrugghen,
The Calling of St Matthew,
1621, 102 × 137.5 cm,
Central Museum, Utrecht.

natural, even intimate, since the warm glow of the candle causes the colours to brighten from the dark background, through the reds of the High Priest's cloak and Christ's undershirt, to the near-white highlights on hand and finger, book and shirt.

Hendrick Terbrugghen, another painter from Utrecht, was in Rome between 1604 and 1614. Nearly all his pictures were daylight scenes, and his subjects and colouring were close to those of some of Caravaggio's early paintings of gipsies and musicians. Terbrugghen's *Calling of St Matthew* also shows his debt to Caravaggio's painting of the same subject, although it is very different. The figures are much closer to us, so close that it is as if Christ is standing beside us, obstructing the daylight which streams in from the left. Christ's dark silhouette, in contrast to the brightly lit, sharply characterised figures on the right, heightens the tension of the relationship. The harmony of cool blues, pale yellows, creamy whites, violets and red-browns is held together by a soft silvery tonality. This lovely open-air effect of Terbrugghen's painting shifts the realistic treatment of the subject from drama to lyricism.

REMBRANDT'S RELIGIOUS WORKS

Rembrandt, born only four years before Caravaggio died and eight years younger than Bernini, never left his native Holland. He

worked first in Leyden and then, for most of his productive life, in Amsterdam, and never saw a painting by Caravaggio. But he was in contact with painters like Honthorst and Terbrugghen who had been to Rome. Through them he learnt something of Caravaggio's realism and use of light. After his move to Amsterdam he developed them to an entirely new pitch of expressiveness, human sympathy, and deep religious feeling.

This religious feeling was a very personal one, derived from his own experience and a deep familiarity with the Bible. Reading and meditating on the Bible took the place in Protestant Holland of Catholic instruction by the priest, meditation on the lives of the saints, and the performance of exercises such as those prescribed by St Ignatius. Rembrandt's choice of subjects was also his own. Whereas Catholic artists like Caravaggio, Bernini, and Rubens painted or sculpted the subjects that were given to them, for display in a particular church or private chapel, there was no such demand from the Dutch Calvinist churches. Artistic commissions from the burghers of Amsterdam, enjoying the wealth brought in by the city's new commercial prosperity, were for portraits, or for landscapes, flower paintings, and the like. There was, however, a market for prints of religious subjects and Rembrandt, as well as being one of the greatest painters of the century, was also the greatest etcher, if not the greatest etcher of all time.

Etchings are printed from plates, usually of copper, on which the artist has first drawn the subject in reverse. Usually it is scratched with a needle through a thin acid-resistant layer of wax. Acid is then applied to bite into the plate where it has thus been laid bare. The whole surface is inked and wiped to leave just enough ink in the grooves so formed to print on paper pressed against it. The process can be varied by also scratching directly into the plate with a harder needle, leaving a slightly rough edge to the groove, which can be either rubbed away or left to give a softer texture to the printed line.

In the *Hundred Guilder Print* (so called because it had earlier fetched that high price at an auction) Rembrandt used the full range of these techniques to create a surface of great richness and subtlety, despite the absence of colour. The subject is a composite one taken from the nineteenth chapter of the Gospel of St Matthew. Christ is shown in Judea healing the sick, receiving little children, and

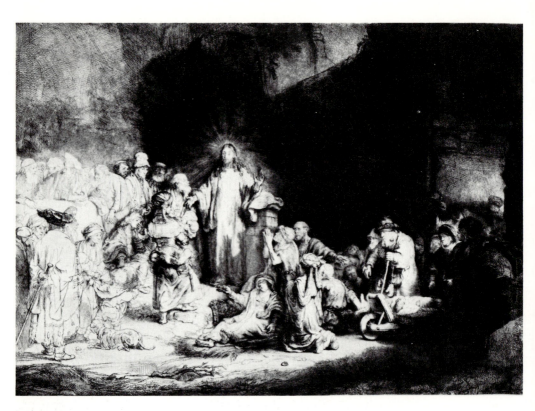

Rembrandt, *Hundred Guilder Print*, c. 1650, etching, 2nd state, 278 × 389 cm, British Museum, London.

teaching. The sick approach from the right, prophetically reminiscent of the prisoners released into the light in Beethoven's opera *Fidelio*. A woman carries forward a young child a little to the left, but is restrained by a disciple just above her. To her left sits the rich young man who has just been told that he should give all that he had to the poor if he wished to have treasure in heaven. And, further to the left, a shadowy group of Pharisees dispute among themselves. Christ stands in the centre looking, with outstretched hand, towards the child. All attention is focussed on him, both by the movements, gestures, and looks of the other main figures, and by the way in which the whole composition builds up towards his raised figure. Contrasts of light and shade are used as much to emphasise the important compositional lines and the psychological meaning as to suggest space and solid form. Though they create an effect of heightened realism this is far from the naturalism of a photograph. Note the way in which the broad areas of dark lead to and emphasise Christ's figure, the way in which the dark hat of the standing man on the left balances the much larger areas of dark on the right and ties in the other figures on the left to the rest of the picture, and the telling

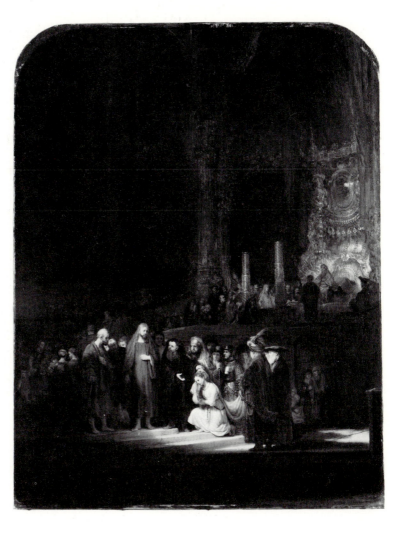

Rembrandt, *The Woman taken in Adultery*, 1644, oil on panel, 83.5 × 64.5 cm, National Gallery, London.

shadow on Christ's robe of the upraised hands of the kneeling figure just to his left. Like Caravaggio, Rembrandt used as models for most of his figures the ordinary people he knew around him – mostly, in his case, the poorer Jews of the area in Amsterdam where he lived.

A comparable painting is *The Woman taken in Adultery*. Dressed in white, she kneels with bowed head in a pool of light beside her accuser who looks up to Christ. His pointing hand forms a bridge between her and the compassionate, simply dressed and barefoot Christ. Other figures stand around; an apostle beside Christ, richly dressed onlookers to the right who introduce the only strong colour into the picture. At a higher level on the right another group advances towards the High Priest on a rich gilt throne dispensing

29

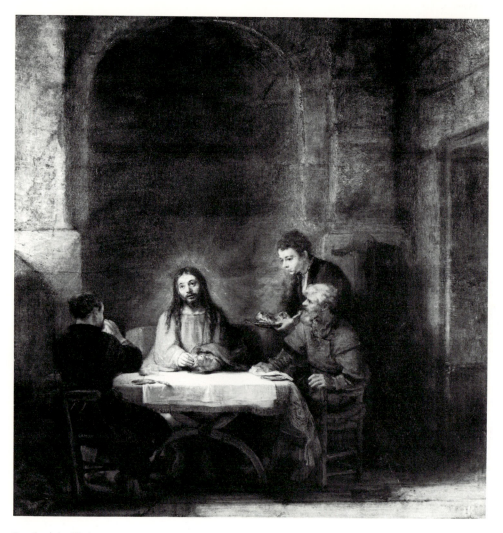

Rembrandt, *Christ at Emmaus*, 1648, oil on panel, 68 × 65 cm, Louvre, Paris.

another kind of justice – the Old Testament law contrasted with that of the New Testament of Christ: 'He who is without sin among you, let him first cast a stone at her.' The setting is now much more clearly indicated – it has almost the theatrical character of grand opera – but the representation is wholly subordinated to the compositional needs of the picture and to emphasising the contrast between Christ's way and that of the Pharisees. The central column firmly anchors the woman at the pivot of the whole composition and the two large gilt candlesticks echo the standing Christ and apostle and link them to the High Priest and the two standing figures to the right.

The contrasts between light and dark in these pictures are as great

as any used by Caravaggio and as dramatic. But Rembrandt's light is not Caravaggio's sharp southern light that picks out forms with sculptural precision so that we can almost touch them; it is a softer light that caresses their surfaces and unifies them with the surrounding space, making this space itself almost palpable. Since his pictures were not made to be set above altars and to have a strong impact from a distance but to be looked at closely in more intimate surroundings, Rembrandt could allow himself a much ampler space around his main subject to create an atmosphere and he could set this subject further back instead of making it almost burst out of the canvas. He involves us with the subject, not by making us feel that we are actually present at and participating in the event, but by subtler means. By suggesting the deepest feelings of those who are taking part he encourages us to share those feelings.

Rembrandt only learnt with experience – partly his experience as a portrait painter – how to do this. As a young painter in Leyden he showed one of the disciples at Emmaus reacting much like Caravaggio's disciples to the shock of recognition of the risen Christ. Twenty years later he gave the subject a quiet timeless majesty, reinforced by the architectural background. His Christ opposite is now clearly related to the Christ of Leonardo's *Last Supper*, and the painting as a whole may indeed have been intended as an allusion to this closely related subject and its deeper meaning.

In his later years, when he was no longer the fashionable success he had earlier been in Amsterdam, Rembrandt increasingly selected subjects of a profoundly human character rather than moments of blinding revelation or mystical experience. Fatherly love, compassion, and forgiveness are the main subjects of Rembrandt's last, and probably his greatest, religious painting. The parable of the prodigal son – who left home with his inheritance, spent it all, and returned home destitute – had interested Rembrandt for a long time. But it was only at the end of his life that he was able to paint its essential message with so much insight and monumental simplicity. The son, barefoot and clothed in a ragged garment, kneels before his father and buries his head against his father's breast. The father bends down and places his hands on his son's shoulders, so that his arms envelop the son's head in an unforgettable gesture of forgiveness and welcome. The two figures stand out in a rich harmony of reds

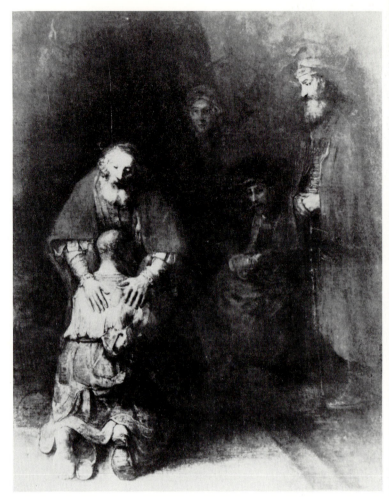

Rembrandt, *The Return of the Prodigal Son, c.* 1669, oil on canvas, 264 × 206 cm, Hermitage, Leningrad.

and subdued, almost golden, yellows against the dark background in which the shape of a tall archway is just discernible. A statue-like onlooker stands to the right adding to the solemnity of the occasion, and other figures emerge from the darkness further back. As in Titian's late works, the paint is applied with great freedom. The forms are often suggested in the highlights by broad thick smudges, perhaps applied with the finger. But this is a large painting and, as we stand back, we are overcome by the awesome power of the whole work.

4 Painting: Flemish colour and exuberance

We saw in the last chapter how Caravaggio's paintings influenced Flemish and Dutch painters in their use of light and in the realistic portrayal of scenes from the Bible. Contact with Italy was fruitful also in the use of colour.

Colour had always been important in Flanders (now Belgium), even in the illustrations added to early hand-written books. This use of colour had been developed and made more natural when Jan van Eyck and Roger van der Weyden started mixing their colour with oil for painting on wooden panels. Their work became known in Italy and was highly prized in cities like Florence and Venice in the later fifteenth century. Venetian artists, in particular, were influenced by it. The Venetian lagoon and its unique light effects made the Venetians particularly sensitive to colour, and the city had direct trading contacts with Antwerp. In its turn the use of colour by sixteenth-century Venetian artists like Titian, Tintoretto, and Veronese influenced later Flemish artists.

RUBENS AND ITALIAN ART

In the seventeenth century the most famous Flemish painter to visit Italy was Peter Paul Rubens. He spent nearly ten years travelling in Italy and he worked for the Duke of Mantua, near Venice. He also went on diplomatic missions to Spain where he saw the royal collections of fine Italian paintings. He copied paintings, often Venetian ones, both for the duke and for himself, to develop his sense of colour and improve his technical skill. He also admired the contemporary Roman painters, Annibale Carracci and Caravaggio, whose realism and dramatic use of light influenced his own work. He even bought a picture by Caravaggio, *The Death of the Virgin*, for the Mantua collection. The model for this picture had been a girl in Rome who had committed suicide by drowning herself in the Tiber.

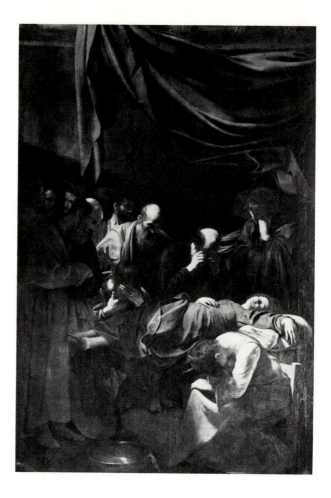

Michelangelo Merisi da
Caravaggio, *The Death of
the Virgin*, 1605–6, oil on
canvas, 369 × 245 cm,
Louvre, Paris.

Her swollen feet and body were felt to be offensive. She is certainly
different from the models usually used for the Virgin, models whom
the painters and sculptors often improved to make them look closer
to the ideal of an attractive woman. (Today photographers similarly
improve on models for fashion photographs by using special lighting
and removing from the negative blemishes and unpleasant details!)

Rubens too knew how to improve on reality, and like Bernini he
loved the beauty of warm living figures, either dressed or naked. He
sometimes worked from living models but his many surviving
drawings show that he also ardently studied ancient sculpture.
Whatever subject he was asked to paint, whether for the Church or
for royal patrons, became a composition of human figures, clothed
or nude, set in unrestricted space, bathed in light. The costume and
draperies provided the colours needed to offset the luminous treat-
ment of human skin, whether it belonged to the Virgin or to Venus.

Rubens could interpret both the mood of the events of Christ's life on earth, and the mood of the idyllic classical world of the gods of pagan antiquity. His rich imagination and complete mastery of the technique of oil painting enabled him to paint the most complex pictures full of strong active figures engaged in dramatic actions.

Rubens' Flemish background had prepared him to appreciate also the warm reds, yellows and greens of Titian's paintings (page 7), and he in turn used a palette of predominantly warm colours. He applied the paint for lighter parts in many transparent layers with little pigment and much oil, so that the underlying layers show through. Rubens always thought as a painter: even when planning his compositions he usually drew with the brush indicating the forms with expressive brushstrokes in a sketchlike manner, setting out the main parts of the composition in areas of light and dark. He built up the figures from dark to light so that they are evoked, not through line, but through more or less transparent colours.

RUBENS' RELIGIOUS WORKS

Rubens returned to an Antwerp that had suffered badly in the war with Spain. Its churches had been sacked in a wave of Protestant iconoclasm that accompanied the initial rising against the Spanish overlords in 1566. Then, with the effective partition of the Low Countries into north (Holland) and south (Flanders) and the blockade of the Scheldt, Antwerp had lost to Amsterdam its former pre-eminence as a port and commercial centre. But, while the north had become predominantly Protestant, it had remained Catholic. There were some similarities with the situation in Rome in the middle of the previous century. However paradoxically, the stage was set for a new flowering of the arts under the patronage of the Church and (in place of the pope) the Spanish regents.

Rubens had already obtained some fame in Italy, and this must have preceded him. Soon after his return to Antwerp he was appointed court painter and was also receiving numerous commissions for large altarpieces and ceiling paintings for the churches. Like Bernini he was without any real rival and made extensive use of other artists as his assistants. He would produce small colour

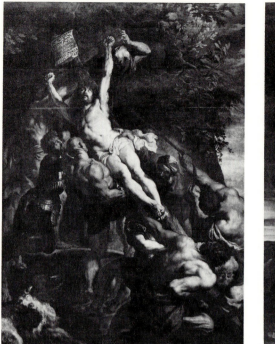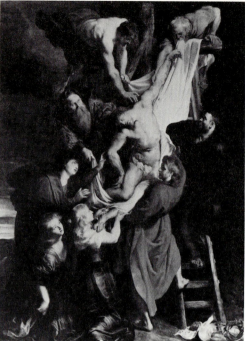

Peter Paul Rubens, *The Raising of the Cross*, *c.* 1610, oil on panel, 462 × 341 cm (above) and (above right) *The Descent from the Cross*, 1611–14, oil on panel, 420 × 310 cm, central panels of triptychs, Antwerp Cathedral, © ACL Brussels.

sketches or perhaps outline the whole composition full size. Under his direction assistants would then do most of the painting, leaving him to add the final touches that brought the work to life. His major scheme of ceiling decoration for a church – the Jesuit church in Antwerp – was destroyed by fire in 1718, and only the sketches survive. But we still have many of the altarpiece paintings.

One of the most impressive is *The Raising of the Cross*. This shows the moment when Christ, who has been cruelly nailed to the huge cross, is heaved up from the ground with ropes and swayed into the air by hefty soldiers. Their sweating bodies and the helpless yet beautifully heroic Christ are sharply lit against a stormy sky. The muscular bodies contrast with the metallic surface of the warriors' armour. They and the hairy dog on the left and the foliage on the right all catch the light in different ways. At the culmination of the diagonal movements and at focus of the theatrical light, the violence and the torture is the head of Christ who, undefeated and still alive, gazes up to heaven in communication with God. He is the calm centre of the picture. Christ triumphs spiritually despite his defeat, and the worshipper in front of the altar can be strengthened in his faith witnessing the gruesome martyrdom. The full drama of the story is especially vivid because the figures are strong, the colouring

36

is brilliant and the translucency of the paint unites the figures with the space around them.

The Descent from the Cross is similarly built up around the diagonal figure of Christ, backed by the white linen cloth. But Christ is now dead, and the calm of the body is echoed throughout the picture. If one tries copying the painting one can see for oneself how the living figures are arranged around the corpse. We may well ask whether this arrangement has much to do with the real needs of a careful lowering movement of the body.

Both paintings are as expressive of the Jesuit attitude as is Bernini's *St Theresa*. Rubens' sympathy with Jesuit teaching was even more directly expressed in two other works for their church in Antwerp – his altarpieces, *The Miracle of St Ignatius* and *The Miracles of St Francis Xavier*. The subject of the second is as complex and the different incidents brought together are as skilfully organised as in Rembrandt's *Hundred Guilder Print*. But Rubens' bold assertion of the faith is far removed from Rembrandt's quiet and intimate reflection on Christ's teaching and healing.

OPTIMISM PERVADES EVERYTHING

Of course a large altarpiece should not really be compared with a relatively small print. The difference does, however, reflect more than this. It reflects both a difference in religious outlook – one Catholic and the other Protestant – and a difference in temperament of the two artists. Rubens was of a much more outgoing nature. He was widely educated as well as travelled and, like Bernini again, very much a man of the world. He was highly successful in all he turned to. Soon after he returned to Antwerp he married the beautiful Isabella Brandt. She died seventeen years later, but he then married the equally beautiful young Hélène Fourment, with whom he lived very happily until his death. His portraits of them are witness to his delight in their presence. He had every reason to view the world with optimism and to enter into the spirit of celebrations of love and beauty with an exuberant abandon hardly matched even by Titian.

One of the most colourful paintings inspired by his happy marriage is *The Garden of Love*, now in Madrid. Are the fashion-

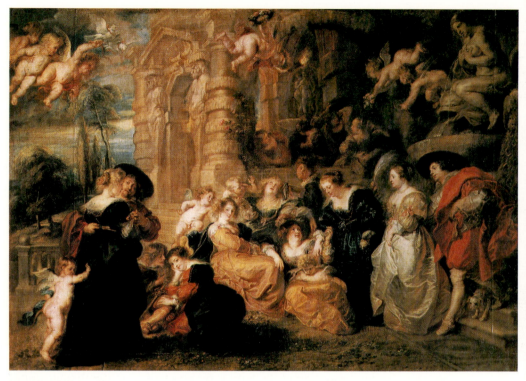

Peter Paul Rubens, *The Garden of Love*, 1632–4, oil on canvas, 198 × 283 cm, Prado, Madrid.

ably dressed, heavy-breasted women in their voluminous silk-satin dresses all inspired by his wives? Is it Rubens himself embracing Hélène on the left? The throng of feminine loveliness seems out of this world, with playful naked cupids tumbling from the sky, and the grandiose palace entrance transporting the scene to a luxurious never-never land. Allegory and real life intermingle through the marvellously rich costumes in warm tones from which the whitish dress stands out. The red male costume gathers up the complexity of the movement and the rhythms, unfolding from left to right. Above the man the stone fountain has come to life and, like a real woman, Venus is pressing her breasts; yet water not milk flows forth. The couples on the steps complete the triangle of the composition, both in space and on the surface of the canvas, while the verticals and curves of the architecture stabilise and echo the forms below.

In numerous other paintings Rubens showed his delight in the beauty of the unclothed female body. His female nudes were not like the ideal classical Venus or like Bernini's Persephone (p. 14). Their flesh is fuller as was the fashion in Flanders at the time. But they are palpitating with life and voluptuously sensuous. Subjects like *The Judgement of Paris* allowed Rubens to indulge this delight to the full.

38

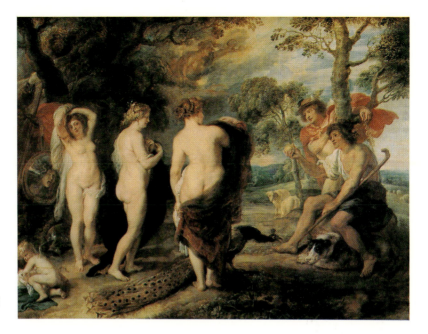

Peter Paul Rubens, *The Judgement of Paris*, *c.* 1632–5, oil on panel, 144.8 × 193.7 cm, National Gallery, London.

Paris, son of King Priam of Troy, was tending his father's flocks when Mercury brought to him the three goddesses, Minerva, Venus, and Juno, and asked him to award a golden apple to the fairest of them. In the later of his two paintings of this scene in the National Gallery, London, Rubens shows the three goddesses standing a little apart in a wooded landscape. Paris sits with his dog at the foot of a tree to the right with Mercury standing over him. He holds up the apple in his right hand, about to award it to Venus who looks modestly towards him between Minerva and Juno. Behind her an infant Cupid plays with the blue robe she has discarded, and this blue is echoed in the distant hills and the sky at the right. The much darker blue of the robe she holds in front of her links her to the seated Paris, while the red robes held by Minerva and Juno carry our eyes to Mercury and the red in the sky above Juno. Here a Fury, unseen by Paris, presages the war that will follow when, as his reward from Venus, he takes Helen as his wife. A path is left open between the groups on the left and right. But the groups are further linked by Juno's peacock, Paris's dog and the two sheep in the middle distance. This is a painting rich in allegorical meaning, but rich also in the tenderness of personal feeling and observation of nature.

39

COLOUR IN FLEMISH AND DUTCH FLOWER PAINTINGS

In one type of painting the earlier Flemish delight in colour continued to be expressed in a way that owed nothing to Italy: this was flower painting. The picture might be simply decorative, like a vase of flowers on a table, but for centuries painters had also used flowers as symbols. Lilies in a vase beside the Virgin Mary symbolised her purity. When openly religious paintings became less fashionable after the religious disturbances of the later sixteenth century, it was natural that other symbolisms should develop – particularly symbols of the shortness of human life. Cut flowers soon wither away, however colourful they may be in the picture, and the bright

Peter Paul Rubens and Jan Breughel I, *Virgin and Child in a Flower Garland*, *c.* 1621, oil on panel transferred to canvas, 85 × 65 cm, Louvre, Paris.

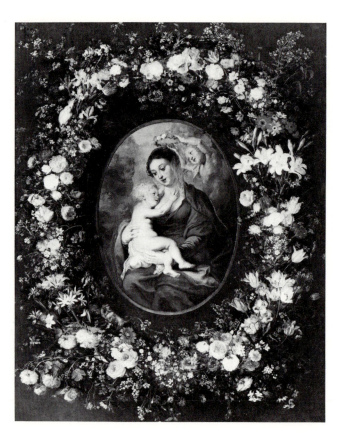

butterfly or moth that flies among the full blooms of a rich bouquet may be dead at the end of the day.

Sometimes religious painting and flower painting were combined. A small painting of the Virgin and Child by Rubens might, for instance, be surrounded by a garland of flowers exquisitely painted by his friend Jan Breughel. Usually, however, the flowers are the main subject. In a painting done early in the century by Ambrosius Bosschaert the Elder each flower is individually observed in meticulous detail and the arrangement is correspondingly stiff. But in a later painting by Jan Davidsz. de Heem a Baroque vitality has been imparted so that 'the flowers fairly leap from their vase'. The colours of the large ones demand all our attention, while the smaller ones recede into the dark background.

During the second half of the seventeenth century the fashion spread to France and England, with a skilful jig-saw of thin pieces of

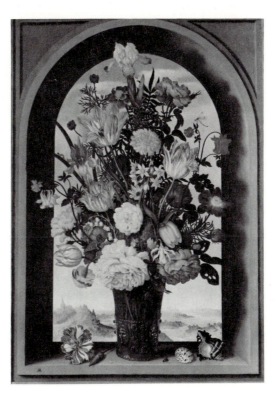

Ambrosius Bosschaert, *A Bouquet in an Arched Window*, *c.* 1620, oil on panel, 64 × 46 cm, Mauritshuis, The Hague.

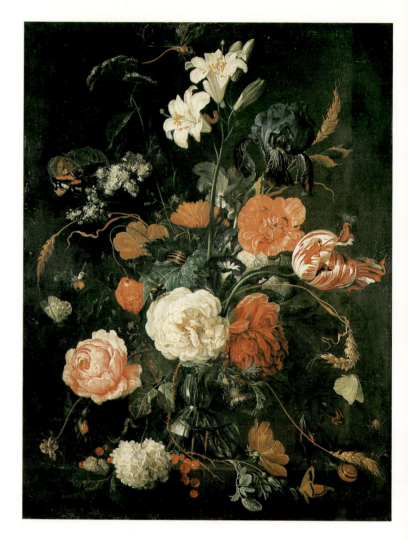

Jan Davidsz. de Heem,
Flower Still Life, *c.* 1665,
oil on canvas, 54 × 42 cm,
Ashmolean Museum,
Oxford.

differently coloured woods, ivory, mother of pearl, and bone
sometimes taking the place of paint. This was a manifestation of a
pleasure-loving age, yet an age in which spiritual realities were never
far beneath the surface.

5 Painting: passion checked by reason

Some seventeenth-century art was less exuberant. We have already referred to the restraint typical of French art in the later part of the century. A similar restraint was apparent even at the beginning of the century in other works by Annibale Carracci. Painting of this kind looked back to those works of Raphael that were notable for their calm harmonious balance, and to earlier works of classical Greece and Rome that had similar qualities – qualities that have themselves come to be known as classical. This harmony and balance is not typical of the world around us. It is a product of the artist's mind and imagination. We should therefore be prepared for it to appeal more directly to our minds than to our emotions.

ANNIBALE CARRACCI AND HIS FOLLOWERS

Annibale Carracci's picture *Domine, Quo Vadis?* is a good starting point from which to develop our understanding of these more classical trends. The story is that, years after the crucifixion, the apostle Peter encountered Christ in a vision on one of the old roads leading out of Rome – the Via Appia. Peter asked him 'Lord, where are you going?'. Christ replied that he was going to Rome to be recrucified in place of Peter, who was fleeing from a likely martyrdom. The painting shows Christ with his cross on his shoulder, the crown of thorns on his head and the marks of the crucifixion on his feet. But it is the risen Christ who has overcome death and demonstrated his divine nature. His beautiful, masculine body, seen frontally and thus most monumentally, is contrasted against the sharpness of the forward-thrusting cross. The body is warm, natural, in motion, with the swirling red cloak repeating the rhythms of the left side of the silhouette. The light of the setting sun strikes from the left and creates a sharp contrast between the lit and the shaded parts of the figures. Peter's profile contrasts with

Annibale Carracci,
Domine, Quo Vadis?,
1601–2, oil on panel,
77.4 × 56.3 cm, National
Gallery, London.

Christ's young face; the colours of his garments contrast with those of Christ. But the diagonal line of the yellow cloak repeats the diagonal of the cross and the figures are thus united, despite the great contrast between the forward-striding Christ and the half kneeling, surprised and somewhat frightened apostle who pulls backwards. The figures are contained within the frame with the help of the columns of a temple on the right and another building on the left, half hidden by a tree whose trunk runs along the picture frame. An evening landscape unfolds in horizontal layers to a horizon interrupted by Christ's head.

Compare this painting of Christ with Bernini's Pluto (p. 14) or Neptune (p. 14). Carracci's Christ strides forward. His right arm and left leg thrust into space, our space, but not with the vehement sensuousness of Bernini's pagan figures. The balanced relationships throughout the painting and the lovely calm landscape temper the mood of surprise.

The balance between the figures and between the colours of the

Guido Reni, *Salome*, *c*. 1640, oil on canvas, 248 × 173 cm, Collection of the Art Institute of Chicago.

draperies, the general balance between the landscape with the buildings and the two figures, and the ease with which the figures move and are surrounded by air and space, give a harmonious atmosphere to the painting. We can call this balance classical because, despite the aggressiveness of the movement, all the force is balanced within the painting, giving a strong sense of restraint and control.

The most classical of Annibale Carracci's followers was Guido Reni, who late in life painted one of his most powerful classical 'grand manner' paintings. The Salome receiving the head of St John the Baptist seems at the very end of the last step of her dance and her beautifully balanced body movements correspond with the rhythms of her draperies. The half circle of the neckline of her brocaded dress is repeated over and over again moving downward with ever larger circular folds of the cloak, finally ending in the hemline of the undergarment. At the centre of all these movements is her face with the gaze fixed on the severed head which lies at the base of the folds of her sleeve, on the horizontal platter. The composition of such a picture is so carefully thought out that the result is larger than life. We are transported into a world where people seem to have a dignity which lifts their actions above the gruesome reality of what has just taken place.

Nicolas Poussin,
*Bacchanalian Revel before
a Herm of Pan*, c. 1630, oil
on canvas,
99.7 × 142.9 cm, National
Gallery, London.

POUSSIN

The work of the French painter Nicolas Poussin links this Italian classical Baroque style with that of the French. He arrived in Rome in 1624 and worked there nearly all his life. At first his pictures were full of movement and exuberance, yet his figures are not as hearty and healthy as those Annibale Carracci had painted earlier. Poussin's figures are removed from this world, idealised human beings with beautiful bodies. In the *Bacchanalian Revel before a Herm of Pan* the dancing figures move rhythmically and their arms intertwine like flowers, holding the composition in equilibrium. The revel is contained within the frame of the picture; the energetic movement is circular and does not really invite us to partake in the idyllic scene.

Poussin was a great admirer of the art of classical Rome – not only of the balanced form of many statues and reliefs but also their calm reflective moods. As he succumbed to their spell he tried to recreate a similar mood in his paintings and his style changed accordingly. *The Holy Family on the Steps* is quiet, serene and fully controlled. . Nothing is accidental and all the forms are carefully planned and

46

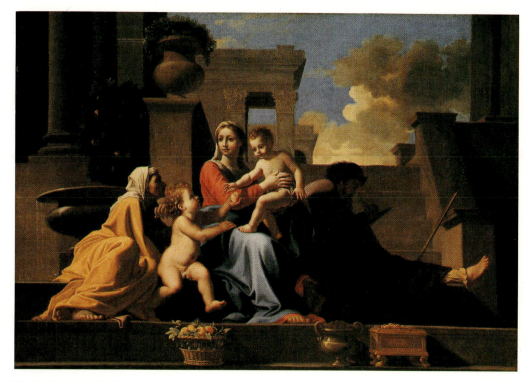

Nicolas Poussin, *The Holy Family on the Steps*, 1648, oil on canvas, 67 × 96 cm, National Gallery of Art, Washington, Samuel H. Kress Collection.

balanced. The classical architecture of strong horizontals and verticals forms sharp silhouettes against the sky. The space is structured with mathematical accuracy. The figures are composed in a triangle. The Virgin herself sits upright while the two children form a chain of movement contained on either side by Anna and Joseph. This controlled composition, where figures and architecture complement one another, is characteristic of the classical phase of the Baroque. The figures almost take on the grandeur and permanence of the architecture. If we compare the Salome by Guido Reni with this painting by Poussin, we can see what they have in common and how the artists can be distinguished from one another.

Poussin had been recalled by the king to France in 1640 but he stayed in Paris for only two years as the commissions he was given, for altarpieces, and decorations for the Long Gallery at the Louvre, were much too large in scale for his talents. He returned to Rome to work for private Italian and French patrons. There he had great influence on another French artist, Charles Lebrun, who studied in Rome for four years from 1642. In 1646 Lebrun returned to Paris and he did prove to have the intellectual, artistic and organisational qualities to take on large decorative schemes. Soon therefore it was

Lebrun who was working for the most spectacular king of the seventeenth century, Louis XIV.

ART AT THE COURT OF LOUIS XIV

Advised among others by his able minister Jean-Baptiste Colbert, the king centralised all the affairs of government not only by taking political, religious and economic matters under his own direction, but also by forcing artists to belong to the Royal Academy of Painting and Sculpture through which they obtained independence from the Guilds. Through this royal patronage the king could create an environment in the royal palaces where architecture, sculpture, gardens, mural decorations, furniture and textiles, music and drama together formed a unified setting for the most powerful monarch in Europe. Lebrun became director of the Academy, where the members and young aspiring artists listened to lectures on proportion, perspective, composition, light and colour, the way to depict emotion and many other matters. The Academy professors told them what they should admire most and proposed the following: first, the ancients; secondly Raphael and his Roman followers; thirdly Poussin. The students copied works of these masters; they also copied plaster-casts from ancient sculptures; later in their studies they were allowed to draw living models.

Through such a strong academic foundation members of the Academy learned to create designs according to an established set of rules. Rules for art may seem a ridiculous notion to us in the second half of the twentieth century, but through such rules Lebrun achieved a unity in artistic taste which made the vast complex of Versailles such a majestic setting for an autocratic king. Artists and artisans had their workshops in one of the wings of the Louvre and from 1667 Lebrun was also the director of the royal furniture workshops where the brothers Gobelin employed French, Flemish and Italian tapestry weavers.

Although Lebrun preached the strictest classical theory, his own large decorative schemes gave an impression of ostentatious luxury, despite their classical themes, quite different from the solemn austerity of Poussin's paintings. The gallery at Versailles, with its

mirrors and silver tables both reflecting the sumptuously painted ceiling, had little classical serenity and restraint. Lebrun's designs for a series of tapestries glorified the king, by showing him impersonating the great Macedonian ruler, Alexander. But there are also strong Roman echoes. Painters and writers had long been fascinated by the idea of the great triumphal processions with which the Romans had celebrated the victories of their Caesars, and which had been commemorated in carved reliefs. The earliest and most famous re-creation in paint was Mantegna's series of huge canvases painted around 1490 for the court of Mantua. Rubens had copied Mantegna's work and Lebrun brought the theme alive once more in a magnificent glorification of his own Caesar – Louis XIV.

His procession moves parallel to the picture plane, backed by

J. H. Mansart and Charles Lebrun, Galerie des Glaces, begun 1678, Versailles.

Charles Lebrun, *Triumph of Alexander the Great*, 1670–82, tapestry, Versailles.

classical buildings. These are composed on Poussin's geometrical principles to create a controlled space. A large statue of an empress on the left seems to hold in place the throng of figures beneath her. Only the rearing horse in the foreground breaks through the restrictions of the space. So although the tapestry is rich in colour and figures, the composition is also very calculated in its effects.

This sort of calculation often makes the work of the more classical artists of the seventeenth century seem insipid to our taste. Passion is so checked by reason that little is left but an empty elegance, so prearranged to the smallest details that it lacks credibility. Nevertheless we can learn to follow those patrons who preferred such pictures in not taking them too literally, and in enjoying the artist's mastery of design and colour and his ability to portray his subject in its essentials.

6 Painting : Baroque portraits

We are so used today to seeing ourselves in photographs that it is hard to imagine that, for long periods in the history of art, even the highest in the land were portrayed only on coins and, perhaps, on their tombs. These were times when status or rank in society counted for much more than the individuality of the person holding it. The 'portraits' were not much concerned, therefore, with the way in which one king differed in appearance from another; and still less

Peter Paul Rubens, *The Marchesa Brigida Spinola Doria*, *c*. 1606, oil on canvas, 152 × 99 cm (originally larger), National Gallery of Art, Washington, Samuel H. Kress Collection.

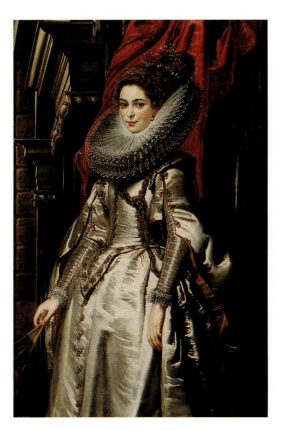

with differences in character. Portraiture, as we now understand it, began in the Renaissance with a new interest in the individual. It had already reached a high peak in the sixteenth century in the paintings of Dürer, Raphael, and Titian. But it was probably in the seventeenth century that we see it most fully developed in range, power of expression, and depth of insight. In our own time portraiture has, unfortunately, suffered greatly from both the direct competition between photographer and painter or sculptor and the excessive emphasis that the photograph has led us to place on a 'likeness'. The greatest artists have sought, above all, to make their portraits seem alive and, secondly, to give them an individuality most characteristic of the sitter. A likeness is achieved almost incidentally and almost unavoidably.

The range of seventeenth-century portraiture can be measured either in terms of sitters or in terms of what the artist was chiefly trying to express. Sitters ranged from popes and cardinals, kings and high ministers of state, to merchants, preachers, and very ordinary people. Some of the greatest artists also often painted themselves. In a commissioned portrait of a king, the majesty of kingship might be the real subject. At the other extreme, an artist like Rembrandt may lay bare the individual soul. Then as now there were, of course, sitters who chiefly wanted a good likeness, and there were artists who gave them little more than this. But this sort of likeness is rarely of much interest to us today, so we shall concentrate here on portraits that offer more than this. Since the outstanding portraits by an Italian artist were Bernini's busts and full-length figures which we have looked at already in chapter 2, we shall concentrate here on portraits by northern artists, though we shall start with one painted by Rubens during his time in Italy.

COURT PORTRAITS OF RUBENS AND VAN DYCK

Rubens painted the Genoese Marchesa Brigida Spinola Doria standing in front of a palace. Originally the painting was even larger so that a garden could be seen to the left and the marchesa was standing on a terrace. The shimmering satin dress contrasts with the sharp, majestic architecture, and the dainty frills of her ruff form a

frame for the lovely face. The textures and colours give diversity, the grand shapes unity, while the light, and the movement of the body, add the needed vivacity. It was unusual for a non-royal personage to be given a full-length portrait and this use of architecture as a device for ennobling the sitter was also new.

Anthony van Dyck learned many lessons from the older Rubens. Both were born in Antwerp, travelled in Italy, and worked for the English Court. Van Dyck developed further what Rubens had started in the portrait of the marchesa. He too had many patrons in Genoa where he worked in the early 1620s. Back in Antwerp he painted refined and sensitive portraits of rich men and women. Maria de Raet is obviously rich and is dressed in the latest fashion of thick silk-satin over a shift of fine white linen with a delicate lace collar. Her curls seem to have been left uncombed on purpose. Between all these rich textures her head and hands are so alive and sensuous that she could step straight out of the picture today. She fumbles with her fan and seems a bit shy and nervous. Perhaps van Dyck saw her as not really a very happy person, as somewhat apprehensive. However she is very much alive, caught in the light from the left, which touches her, but leaves the rest of the room dark

53

in the same way that Caravaggio had concentrated light earlier in the century.

When van Dyck became the court painter for Charles I of England his imagination was stirred to devise a style of portrait new for him and totally new to people in England. Not only the royal family but all members of the aristocracy were normally painted full length, in settings of classical columns and shimmering rich curtains, probably very unlike their normal surroundings. But the setting served to emphasise any refinement they possessed, and underlined the gulf between them and mere commoners. A royal portrait, of Charles's queen, shows how van Dyck could make a very grand scene lifelike, with just the right touch of informality. Queen Henrietta Maria and her dwarf were possibly going for a walk, but she has just stopped him, holding her hand on his monkey. The apparent ease of the composition and the movement should not prevent us from admiring the skilful art of the painter in composing the picture through a most complex arrangement of shapes. A strong diagonal from the left front to the right top is established by the columns and the gold braiding. These verticals are repeated less deliberately by the downward movement of the falling curtain, the hand holding the fold of the sumptuous dress, and the parapet obscured by the dwarf. He moves forward, only stopped from entering our world by the curved step of the terrace. The sharp curve at the bottom is picked up by the curve of the splendid black hat with the huge rim framing the Queen's face.

The elegance which van Dyck bestowed on his sitters derives not only from their settings or from the composition, but from his treatment of their persons. He gave them beautiful hands with very long fingers and made the features of the face a bit more regular, leaving out blemishes. In the court portraits he beautified the sitters and by doing so he endowed them with enviable qualities in the same way that models in fashion magazines are today presented for the envy of other women. Photographers similarly manipulate the light, the movement of the models, the setting, the wind breathing through the light materials of dresses. The standards of portraiture thus set by van Dyck in the 1630s continued to inspire English portrait painters for another two centuries. Both Gainsborough and Reynolds owed him considerable debts.

above
Philippe de Champaigne,
Cardinal Richelieu,
1635–40, oil on canvas,
260 × 178 cm, National
Gallery, London.

above right
Hyacinthe Rigaud, *Louis
XIV*, 1701, oil on canvas,
279 × 180 cm, Louvre,
Paris.

FRENCH COURT PORTRAITS

In France too, fashions were set by the court and already in the 1620s Cardinal Richelieu was bringing his authority to bear on taste as well as politics. As secretary to Queen Marie de' Medici, who was Regent for her son Louis XIII, Richelieu commanded a power which increased when he became the chief minister of the young king. In 1635 Philippe de Champaigne, a Flemish master working in France, painted the cardinal. The exuberance of the red silk robes and golden leather hanging is checked by the simple triangular design and the tiny but realistically painted head. The movement of the fingers and the hand repeat the movements in the red cloak, adding vitality and eloquence to the commanding figure. Rubens, van Dyck and Bernini had led the way for this fine, stately, full-length portraiture, but in France vitality was kept in check by the classical simplicity of the main lines of the composition.

By the end of the century, when Louis XIV had established himself as the most powerful ruler in Europe, convinced of his mission to govern by divine authority, such restraint was no longer

55

felt necessary. Hyacinthe Rigaud's portrait tells us little about the private character of the king, because all available devices are used to diminish the human and to enlarge the royal side of the king. The grand setting of platform, throne, classical column and theatrical draperies all play their part. The king, with outstretched arm and hand on hip, in one bold sweep takes possession of the vast space. Curves tumble down and are repeated by different textures and different colours. The light divides and unites elements to enlarge the grandeur of the figure even further. The pattern was set, and throughout the next two centuries kings and queens, emperors and princelings took up this pose to express their lofty status.

GROUP PORTRAITS OF THE DUTCH BURGHERS

In Holland the political climate and social structure were different from those of Italy, Flanders, England, and France. The war with Spain resulted in the establishment of an independent republic. The princes of the House of Orange, who had led the revolt, never became all-powerful kings, so that there was never courtly patronage on a grand scale. Most power and wealth was in the hands of the burghers. It was the shipbuilders, preachers, doctors, merchants, and bankers who built most of the fine new houses and wished to have themselves painted. Public commissions were mostly for group portraits to hang in the city hall or other meeting place. We shall now look at two of these before turning to the individual portraits of Rembrandt's later years.

To protect the country from attacks by troops hired by the Spanish king, the burghers in each town had organised militia companies. These local homeguards continued to exist (though largely for ceremonial purposes) well into the seventeenth century. In a picture by Frans Hals we see some of them merrymaking (p. 58). To group so many figures together in a lively way is difficult. A photographer has the same problem when arranging groups at a family dinner or at a wedding banquet. Frans Hals found an alternative to the usual way of showing two rows of people divided by an oblong table. He broke up the large group into two smaller ones, yet the groups connect and balance. This is a happy gathering;

so look at how Hals enlivened the basic composition and repeated the rhythms of postures and collars. The colours are predominantly black and white for costumes and collars, orange and blue for the sashes and banners, again giving variety with a limited number of colours. The corner of the room chosen by the company for their party is lit by sunlight, and even the shadows seem luminous. This brightens the whole tonality of the picture. Because each man paid the same sum of money to the artist, Hals had to give each sitter equal prominence. Rosy health shines from their faces and their sparkling eyes are alert. It must have been a noisy party!

Fifteen years later Rembrandt was asked to paint a similar group. In the painting misleadingly christened *The Night Watch* (on account of its very dirty state in the late eighteenth century) Rembrandt shows the company of Captain Cocq being ordered by him to march out from the city gate, which is seen in the background. With great daring, Rembrandt has shown them not as an orderly group but in the most lively disorder as they hurriedly assemble and prepare to march. It is a very large painting. The figures are life-size or slightly more. This, and the captain's out-stretched hand and the pointing pikes and guns, make us feel that we are present, while the dramatic lighting and the suggestion of movement everywhere add to the excitement. Yet what we are looking at is as far as it could be from the confused blur of images that we should see if we witnessed a comparable scramble by a real-life group of amateur soldiers. Pictorially everything is perfectly ordered and in its place. How has Rembrandt managed this without loss of credibility?

To answer this question we must look at the colour harmonies and, even more, at the geometric basis of his design. The main colour harmony is between the yellows of the lieutenant's uniform and the dress of the girl running through the group to the left of the captain, and the reds of his sash and the uniforms of the men with guns to the left of the girl and behind the lieutenant. These colour accents are related to one another and they are picked up again elsewhere. Now look again at the lieutenant's pike and the captain's staff, and at the guns, the pole of the standard, and the most prominent lances. All the nearer ones point in different directions towards us, the lieutenant's pike to indicate the intended direction

Frans Hals, *Officers of the Civic Guard of St Adrian at Haarlem*, 1627, oil on canvas, 183 × 266 cm, Frans Hals Museum, Haarlem.

of march. But all are seen in such a way that, on the canvas, they are either parallel to this pike (if to the right of the captain) or at right angles to it (if, like his staff, they are to the left). This second alignment is also that of the drum, which is shown as if inclined away from us. A hidden geometric order thus holds together precisely those elements of the composition that make it most lively.

REMBRANDT'S REVELATIONS OF THE HUMAN SOUL

Though each individual in *The Night Watch* is alive like those in Hals' earlier group, we learn little about what sort of people they were. Perhaps Captain Cocq and his men were not very interesting out of uniform. Rembrandt also painted many more intimate single or double portraits ranging from objectively recorded faces to others that give the deepest insights into the human soul. There are so many to choose from that we cannot do more than take a first look at the breadth of his genius.

In Holland, Protestant ministers were on the same social level as doctors and lawyers and some Protestant sects had leaders from

58

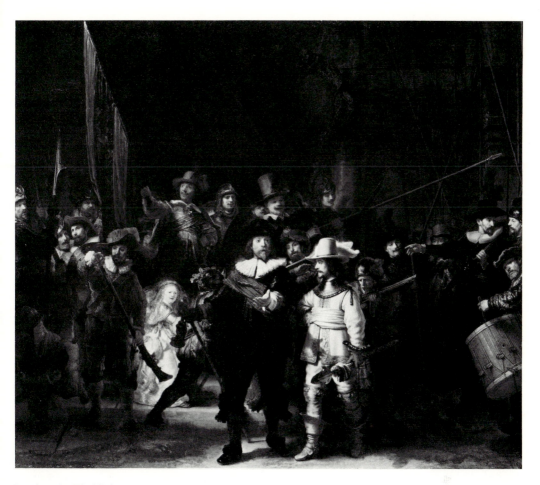

Rembrandt, *The Night Watch*, 1642, oil on canvas, 359 × 438 cm (originally larger), Rijksmuseum, Amsterdam.

their own congregations. These men might not be theologians but they preached and counselled, using the Bible to guide them. The Mennonite preacher Cornelis Anslo was such a man. We know that Rembrandt studied his face and personality thoroughly because we have two fully detailed chalk drawings, one of which served as a study for an etching, the other for a painting.

Anslo's outstretched hand is a characteristic gesture for a preacher. A contemporary poem, probably composed to be printed under the etching, praises Anslo as a fine preacher: '. . . who wants to see Anslo must hear him'. Rembrandt used this gesture over and over again as a centre of interest in a composition, and he used it to convey many meanings. Looking at the three reproductions here, we can imagine ourselves in the place of one of Rembrandt's many pupils working with him in his large house and discussing with the master ways in which to portray Anslo. We can see that Rembrandt

far left
Rembrandt, *Cornelis
Claesz Anslo*, *c*. 1640, red
chalk, pen and wash
24.6 × 20.1 cm, Louvre,
Paris.

left
Rembrandt, *Cornelis
Claesz Anslo*, 1641,
etching, 18.6 × 15.7 cm,
Rijksmuseum,
Amsterdam.

changed the sitter through the different versions and added the
woman in the painting. We might ask whether he has intensified the
speaking in the full-length drawing and the *hearing* in the painting.
Nobody knows for certain the meaning of the two snuffed candles,
one half gone and the other completely burned up. They may refer
to the strong Anslo with a lot of life still to come and the small old
woman. Or they may refer to death, which is possibly the subject of
Anslo's discourse. Had the woman been crying and is he using
words from the Bible on the table to convince her of God's help in
her troubles? The spiritual contact between these two people is
strongly present in the picture and Rembrandt's capacity to depict
this mysterious atmosphere between and around the figures keeps
us searching for the message the figures convey. Not all his works
have this quality, but it is seldom totally absent.

One of Rembrandt's most loved paintings is his so-called *Jewish
Bride*, again an enigma. Although the features of the couple are
individual and distinct we do not know who they are, or even
whether the painting was meant to be seen as a portrait. Perhaps the
subject is biblical: Jacob and Rachel or Isaac and Rebecca, or
Rembrandt's son Titus and his young bride dressed as biblical
characters. Young people in Amsterdam in the middle 1660s would
wear very different clothes, but fancy dress has often been used to
prevent a portrait from looking old fashioned within a few years.
Whoever they are, or whatever story they enact, the love between
them is tender, sincere and timeless. Love makes us feel glowing,
happy and warm and here the rich reds and yellows glow against the
soft brown and transparent beige of the background, conveying the
feeling of love visually. The brocaded costumes are painted with
thick layers of paint. With the handle of the brush Rembrandt
scratched in the thick wet paint so that the light falling on the
painting would be scattered by the uneven surface. The thick paint
sparkles in the light. Yet on the faces and the background the
transparency of the layers of thin paint gives an effect of luminosity.
The light dances over the surface as it does over richly worked silk.
It sinks into spaces, into soft transparent gauze, hands and faces.
The tenderness of the soft light, the tenderness of the couple
towards each other and the tenderness of the painter's careful
manipulation of the paints and colours transfigure two people into a

left
Rembrandt, *The
Mennonite Preacher
Cornelis Anslo and a
Woman*, 1641, oil on
canvas, 172 × 209 cm,
Gemäldegalerie, Staatliche
Museen Preussischer
Kulturbesitz, Berlin-
Dahlem.

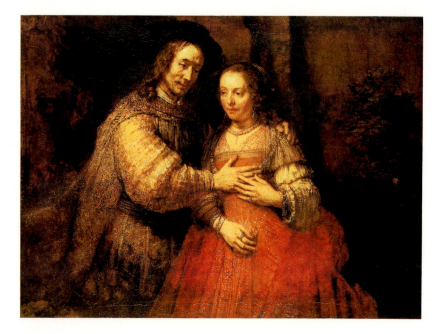

Rembrandt, *The Jewish Bride*, c. 1666, oil on canvas, 121.5 × 166.5 cm, Rijksmuseum, Amsterdam.

visual love poem. Vincent van Gogh later admired this painting so passionately that he wrote to his brother: 'Do you know that I would give ten years of my life if I could sit there before this painting a fortnight, with nothing but a crust of dry bread for food.'

Throughout his life Rembrandt also closely studied his own face, its features, expressions, grimaces, the different textures of skin and hair, in many poses, headdresses, costumes and light conditions. He watched this face as it changed from that of a young man caricaturing or beautifying himself, through his years of worldly success in which he showed himself enacting the Prodigal Son or the Renaissance courtier, to his maturity when bereavement and sorrow were making their marks. Yet even then his strength of character forced him to continue this self-analysis by facing the mirror to look at the effects of bankruptcy, anxiety and early old age. We meet him in the next picture when he is about fifty-four in the act of painting himself, with palette, brushes and painting stick in his left hand. With near majesty, he looks out on our world from the studio where he resides, certain that his human dignity cannot be destroyed as long as he can paint and create.

Rembrandt's sensitive and humane approach to every situation is summed up in this acceptance and understanding of his own figure in the mirror. The heavy-set figure is monumental despite the absence of rich impressive clothes or grand surroundings. His

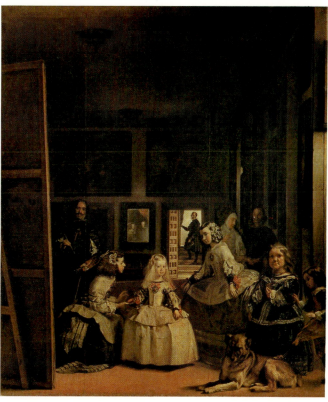

above
Rembrandt, *Self Portrait*, *c.* 1660, oil on canvas, 114 × 94 cm, Kenwood House, London.

right
Diego Velazquez, *Las Meninas*, 1656, oil on canvas, 318 × 276 cm, Prado, Madrid.

strongly three-dimensional head stands out firmly against a light back wall with two large circles drawn on it, perhaps to suggest maps of earth and the heavens. In spite of all, his creative powers are even stronger than before, and his self-respect is fully intact.

VELAZQUEZ

Before we leave portraiture we must look at a picture by one of the greatest of all portrait artists, Diego Velazquez. Portrait painting in Spain had developed along somewhat different lines. Here the patron was King Philip IV, and though the country at this time was declining politically and economically, she still ruled a great empire. Her lands in Italy and Flanders kept Spain in touch with artists working there. Velazquez had become the court painter to Philip IV in 1623, and until his death in 1660 did many of his finest portraits for the royal family.

It is not possible to classify *Las Meninas* (The Maids of Honour)

in the same way as the portraits we have looked at so far because the picture is a mixture of all kinds of portraiture. It contains the self-portrait of the painter, the royal portraits of the little princess in the middle and the king and queen in the mirror, the secondary portraits of the ladies-in-waiting and the very compassionate portrait of the woman dwarf with her dog. A relaxed moment has been chosen. The soft daylight alternates with shadow so that we feel we share with the group the space of the large room; indeed we stand in the same place as the king and queen and this makes the domestic reality of the scene very ambiguous. Here and there the paint is laid on in thick brushstrokes indicating only the embroidery, braids and ribbons, elsewhere the texture is infinitely refined with layers of the thinnest paint used carefully to model the little girl's face and capture the luminosity of the tender skin. Air and space abound yet the strong horizontals and verticals prevent us from getting lost in the large room. It is a fascinating picture, forever full of unanswered questions, dreamlike yet so real; in another world, yet we are present.

7 Painting: landscapes, townscapes and interiors

It was only in the seventeenth century that artists began to treat the landscape as a subject in its own right. Earlier artists – Flemish, German, and Italian – had sketched the landscapes they knew best or saw in their travels. They had then used these sketches as a basis for the backgrounds of paintings with biblical or mythological subjects. Often the background landscape reflected the mood of the main subject; poetical, lyrical, mysterious, or threatening. Sometimes, as in several of Giovanni Bellini's religious paintings, this landscape was painted with a love of detail and an eye for the unifying touch of natural light that has never been excelled. Subordination of the landscape to the needs of the main subject meant, however, that direct experience of the real landscape – the impact it makes on us as we walk about in it – was seldom expressed.

To express in a painting the direct experience of a landscape is not as easy as it might seem if we have never attempted it ourselves. The real landscape is all around us; not confined within a frame. It is never completely still. As we move through it innumerable details compete for our attention, some near, some far away. And the light continually changes. Selection and arrangement are essential. The difficulties are reduced, but not eliminated, if we move to the man-made surroundings of the town or street, or move indoors. But the challenge was one that appealed to seventeenth-century artists who, more than their predecessors, sought breadth and unity and even the infinity of the heavens. Patrons remained chiefly interested in the kinds of subject that we have already considered, but there was a market for biblical and religious scenes in which the landscape setting that caught the mood of the story became, really, the main subject. In Holland the changed conditions referred to in the previous chapter created an entirely new market for straight factual records of the land so recently won, and for more intimate records of life indoors. There were also artists – notably Rubens and Rembrandt – who turned to the landscape more as a personal choice and source

of spiritual refreshment in later life or in times of stress. Different artists transmuted the direct experience, or the memory of it, in different ways.

FLEMISH LANDSCAPES: RUBENS' GRAND SWEEP

We have already seen a glimpse of Rubens' ability to capture the aspect of the landscape of his native Flanders and fit it to the mood of a classical story in his *Judgement of Paris* (p. 39). At about the time this was finished he acquired a country house, the Castle of Steen, and increasingly abandoned the busy life of Antwerp for the quieter life of the country. His great landscapes date from this time. They are vigorous, optimistic, exciting, and among the most Baroque (in the sense referred to in the introduction) that we have.

Peter Paul Rubens, *Landscape with a Rainbow*, 1636–8, oil on panel, 136.5 × 236.5 cm, Wallace Collection, London.

The *Landscape with a Rainbow* was probably painted as a companion to a well-known painting of the castle itself now in the National Gallery in London. Just like a Baroque architect, Rubens

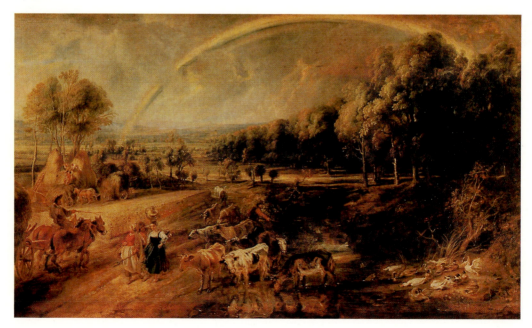

relies on horizontals and verticals, curves and diagonals, light and shade, small elements and grand all-embracing ones, to give the effect of movement sweeping right through space to the distant horizon. The different parts – cattle, figures, and wild life in the foreground; earth, foliage, trees, and sky – complement each other. Each is just a part of a single grand conception and is kept in its place by the light that moves over all and by the colour harmonies and the brushwork. Much that might normally seem commonplace is, in this way and by the choice of an unnaturally high viewpoint, made splendid and deeply moving. Even at the end of his life we see that Rubens never lost his *joie de vivre*.

DUTCH LANDSCAPES: THE LOOK OF THE LAND

Jan van Goyen, *View of Leyden*, 1643, oil on panel, 39.8 × 59.5 cm, Bayerischen Staatsgemäldesammlungen, Munich.

Apart from Rembrandt, the painters of the Dutch landscape were not great masters like Rubens who turned to it from the representation of subjects of great religious, moral, or human significance.

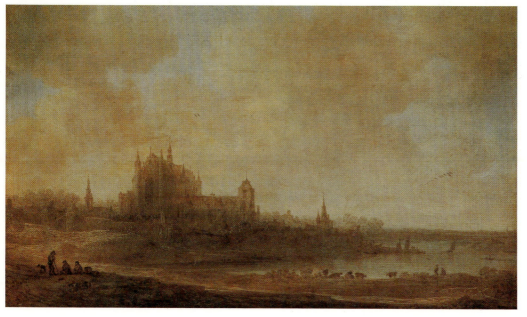

They painted little else and were inspired directly by their love of the land and by a natural curiosity about its ever-changing appearance – a preoccupation with appearances that was another characteristic of the time. They observed the landscape's varying moods, its wide vistas and open skies, its rivers and canals, its trees and windmills, farms and bridges; and they faithfully recorded these in innumerable small sketches as well as in finished paintings.

Some, like Jan van Goyen, never tired of sketching and painting the low river scenes of the marshy lands around his birthplace Leyden. When he went further afield he searched for similar scenes which he painted over and over again, only varying the immense skies (which might take up as much as seven-eighths of the total picture). He managed to keep the vast expanse of sky united to the strip of land by keeping well within the unity of a grey-brown tone – as if the days were always dull. Only later in his career, when the palettes of all the Dutch painters became more colourful, did van Goyen allow the clouds to part so that the blue sky could brighten up the green trees, the sails of the ships on the lively river, and the men in the boats with their coloured blouses. He had learned that by harmonising the tones of the colours he could hold them together, so that the bright red would not come too far forward, and the soft blue fall back beyond reach. Indeed the colours could now be manipulated to aid the sensitive placing of elements in space. Other painters were similarly excited by the search for just the right placing of the elements in a largely featureless flat landscape under a cloudy sky, where only the tower of a far away church arrests the eye for a moment and keeps it there long enough to act as the pivot around which everything else is balanced.

Between Rubens and this apparently unemotional, uncomplicated, relaxed, factual and naturalistic approach to landscape lie many variations: some are more powerful, such as Jacob van Ruisdael's; some more romantic, such as Rembrandt's; some fantastic, such as Hercules Seghers's; some lyrical, such as Aelbert Cuyp's. For all these masters the land itself was the inspiration. They searched for nature as they experienced it personally, and then as they re-experienced it by turning the initial experience into a painting back in the studio.

Nicolas Poussin, *The Burial of Phocion*, 1648, oil on canvas, 116 × 175 cm, Louvre, Paris.

Claude Lorraine, *Landscape with the Marriage of Isaac and Rebecca*, 1648, oil on canvas, 149 × 197 cm, National Gallery, London.

CLASSICAL LANDSCAPES: THE ROMAN CAMPAGNA

Nicolas Poussin (whom we have met already, p. 46) and Claude Lorraine were two French painters who lived practically all their artistic lives in Rome. They were strongly affected by the beauty of the countryside around Rome – the Campagna – with its lakes, hills and mountains in the far distance, and the seashore to the west. Direct experiences were noted down in marvellous pen sketches and brush drawings in deep brown sepia ink. Back in the studio these

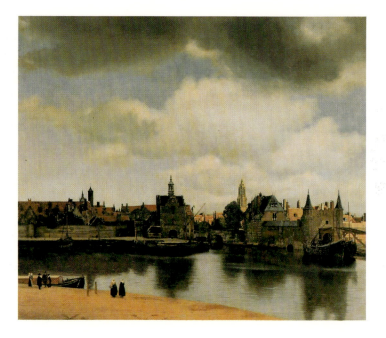

Jan Vermeer, *View of Delft*, *c.* 1662, oil on canvas, 98.5 × 117.5 cm, Mauritshuis, The Hague.

impressions inspired, or sometimes provided the detail for, contrived compositions. In these idealised landscapes the positioning of trees, water, classical buildings, ships, and even human figures, were all calculated to achieve an overall balance. This balance was maintained not only between sky and land, trees and water, foreground and vista, but also between light and dark, horizontals and verticals. Diagonals, so indispensable to the Baroque artists, lead smoothly from foreground into background.

These are not the large curved sweeps which quicken the pace in Rubens' paintings of the Flemish countryside. Here, close to Rome, the mood was timeless, the country no longer young, the buildings classical, whether looking as if they'd just been built, or ruined. The figures are subordinate to their surroundings but take their part in these grand visions of classical or biblical scenes. The natural elements of landscape and the light observed at different times during very still days were used to create an ideal world where everyday experiences could barely take place. Occasionally shepherds wander among the ruins, but they too are idealised and wear classical costume, hardly reminding us of genuine rural life. Pastoral is the word used for these paintings and it is also used in connection with poetry and music. It conjures up a visionary land, where, in a dreamy atmosphere, man and beast are at one with nature, undisturbed and glowing in an eternal bliss of calm diffused sunlight.

70

Jan Vermeer, *Young Woman Reading a Letter*, *c.* 1665, oil on canvas, 46.5 × 39 cm, Rijksmuseum, Amsterdam.

Classical landscape, classical buildings, classical figures, classical compositions have the common denominators of harmony, balance, stillness, timelessness.

DUTCH TOWNSCAPE: VERMEER'S DELFT

These characteristics remind us that there is another sense of the word classical, one that describes the *View of Delft* by the great Dutch artist Jan Vermeer. This is a picture of his native city painted from the side of the water which encircled the town. He has seen the repetitions of horizontals in the roof-lines, of small diagonals in the triangular gables, of curved arches in the gateways and the bridges. The small strip of buildings echoes the expanse of water in which they are reflected with calm haziness. More than half the picture is occupied by a sky covered with thin clouds through which the sunlight has broken just enough to sharpen the details of the tower and the roofs far behind the bridge. The motif of the little Dutch town and the poetic simplicity of the vision are so different from Poussin's self-conscious intellectual approach, yet the order Vermeer imposed on his townscape does have something mathematical about it, something like Poussin's order. The exact relations between the strengths of the colours and the effect of light on coloured forms,

71

either direct or reflected, create a rigorous unity throughout the painting. All the elements are placed in space with unerring certainty.

DUTCH INTERIORS

A comparison with Vermeer's *Young Woman Reading a Letter* also shows that the word classical, in the sense of harmonious, calm and balanced, can indeed be applied to works of art that have nothing to do with classical Rome. The woman stands in a whitewashed room in front of a large map which hangs on the back wall. She is wearing a blue padded jacket. A table, with a book, open workbox and shawl, and two chairs covered in blue seem to frame her. A diffused light from an unseen window fills the room with a unifying radiance. This light, the harmony of colours and shapes surrounding her, and the balance of the near verticals and horizontals framing her, lift this plain woman up to an existence out of time that leaves everyday reality behind. Vermeer has brought out not the individuality of the woman, as in a portrait, but her universality.

With this painting we have moved from outdoors to indoors. The Dutch wanted to have in their houses pictures showing domestic occupations. These are called genre paintings and they may have been popular because religious art was not in favour in a Protestant society. Scholars in recent years have also suggested that there may be hidden, moralising meanings to the pictures. So many scenes are connected with virtues and vices: love, death, laziness, prostitution, avarice, fidelity. Whatever the reason, people wanted to buy the pictures and artists wanted to paint them, especially because they gave such scope for their fascination with the effects of light. Vermeer's interiors show how, through the depiction of light, very simple scenes can shine with the sanctity of a much deeper reality.

We can recognise similar preoccupations in the fine gradations of light in Saenredam's interior of St Bavo Church, Haarlem. Saenredam was interested in space as well as light, and was fascinated by the mathematics of perspective, just as the scientist Newton was at this time. There is a delicate yet daring juxtaposition of the near and the far away, leaving us with a tantalising desire to be

Pieter Jansz. Saenredam, *Interior of St Bavo Church, Haarlem*, 1636–7, oil on panel, 59.5 × 81.7 cm, National Gallery, London.

Emanuel de Witte, *Interior of a Church*, 1668, oil on canvas, 98.5 × 111.5 cm, Museum Boymans-van Beuningen, Rotterdam.

drawn into the sun-drenched distant space. The church interiors of Emanuel de Witte, later in the century, are a little more colourful, with figures in bright skirts, with gravediggers and little dogs. The light too is lively and sharp, throwing patterns on floors and walls.

A similar interest in juxtapositions of colours and sharper light is

73

Pieter de Hoogh, *The Card Players*, 1658, oil on canvas, 76.2 × 66 cm, Buckingham Palace, London.

seen in pictures by Pieter de Hoogh. At first we are attracted by the figures and what they are doing, by the skilful texturing of all the still-life details, but soon we discover his fascination with perspective and space, with verticals and horizontals, with nearby and faraway light effects and with the delicate gradations needed to lead our eye carefully from one to the other. As with lines in poetry, we have to retrace our visual experiences, read surfaces and lines together, measure and balance shapes to understand their relationships, follow up lines to find the hidden intersections. Only when looking at the originals do the colours make their true values known. Their variations and tones in light and shadow bring the whole painting together just as the sounds of different instruments are brought together in an orchestra. Nothing can be added, nothing taken away, everything seems locked into place, yet lively and living: God's presence in the smallest part of His creation.

8 Architecture and the unification of the arts

Seventeenth-century architecture was meant to impress. All the major commissions were for palaces or churches. Kings, princes, and others in positions of power wanted to impress one another and those subject to them with that power. The Catholic Church – which was responsible for nearly all new church building – wanted to proclaim the triumph of the Catholic faith. It also regarded the church building itself as the House of God, while rulers like Louis XIV of France regarded themselves as ruling by Divine right. A similar splendour was thus felt to be appropriate to both palace and church. All the arts could, and did, contribute to it. Sculpture and painting usually played an important part. We should also try to visualise church interiors and palace reception rooms as the settings for splendid religious or courtly ceremonies enacted in richly coloured dress and to the accompaniment of music by composers like Corelli, Scarlatti, Vivaldi, and Purcell. But it was always the architectural setting that made the first impact, and the recognition of this led to as much emphasis on the exterior of a building and on its immediate surroundings as on its interior. Similar emphases had been known in ancient classical times, but in the Middle Ages, and even in the Renaissance to a large extent, buildings had tended to turn their backs on the outside world.

THE GRAND DESIGN

Nowhere can the change in attitude be better seen than at St Peter's in Rome. We have seen that Michelangelo had intended to give the church a domed symmetrical cross form. The perfect symmetry of this form was to be varied only by a huge pedimented portico, like that of the Pantheon, on one side. He probably envisaged all the older surrounding buildings being demolished when this was completed, so as to leave the church isolated like some similar, smaller,

Gianlorenzo Bernini,
St Peter's, Rome,
colonnade, 1657–66.

sixteenth-century churches. If so, this plan was never carried out.
The longer nave built by Maderna replaced the intended portico.
This nave was given a broad new façade of no great distinction
but high enough largely to obscure the main dome, now a consider-
able distance behind it. An open space with irregular boundaries
stretched in front of it, with a re-erected ancient obelisk near its
centre. This space served not only as an approach to the church but
also as a place where large crowds could assemble to receive the
papal blessing.

 With customary brilliance Bernini transformed it into the
grandest approach imaginable and, at the same time, he largely
made good the shortcomings of Maderna's façade. Around the
obelisk he constructed two great covered colonnades. With giant
columns, four deep, these sweep in continuous curves to left and
right to enclose a huge oval – like two welcoming and embracing

Charles Lebrun, Louis Le Vau, and Claude Perrault, Louvre, Paris, east façade, 1667–70.

arms, as Bernini himself said. These were then connected by straight arms to the two extremities of the church façade. Being considerably lower than this, and being splayed out in plan towards it, these arms exaggerate its height by simple contrast and make it appear nearer than it is. The aerial view reproduced here gives some idea of the layout. Only by walking between the columns of the colonnades and across the vast central space can one really appreciate its scale and character. For those on their way to the church itself, it is, of course, only the prelude to the dazzling interior to which Bernini's baldacchino and setting for St Peter's chair contribute so much (see pages 18 and 19).

It was as the colonnades and St Peter's chair were nearing completion that Bernini made the bust of Louis XIV. After being torn by wars earlier in the century, France had emerged as the most powerful state in Europe, and the king, advised by Colbert, wanted to be better housed. Bernini was called to Paris to discuss designs for the completion of the Louvre Palace in the centre of the city. He made several proposals, each with façades dominated by attached columns, or pilasters, rising continuously through the two main floors. None was built. The commission was handed to the three leading French architects, Lebrun, Louis Le Vau, and Claude Perrault. The influence of Bernini is nevertheless apparent, though it is modified by the typical French restraint. At first sight we might even say that the façade is little more than an opening-out of a Roman classical temple. But we soon see that the columns are paired, that the centre and end sections project slightly, that they contain arched openings and other details that would never be found in a classical temple, and that the whole façade is a complex unity focussed on the centre to give a single powerful overall impression. Seventeenth-century architecture, in general, uses the columns,

77

Louis Le Vau, J. H.
Mansart, and André Le
Nostre, Versailles, 1669
onwards.

entablatures and other elements of classical architecture, but in new ways.

Space in the centre of Paris was, however, limited. The Louvre could never become quite as grand a gesture as Bernini (and Michelangelo) had made of St Peter's. Attention turned to what had originally been just a shooting lodge at Versailles. This was successively enlarged into the grandest of all palaces. We have already seen something of its internal decoration. Its outstanding feature is, however, the complete integration of palace and surroundings. On the side from which it is approached a spacious forecourt leads to a deeply recessed entrance façade. On the opposite side the centre projects forward with wide spreading wings to left and right, all looking out on formal lakes and gardens stretching to the far distance.

Though Versailles was never matched in splendour, it became the model for many other palaces built towards the end of the century and during the following century. In England one thinks first of Blenheim Palace. Wren's Greenwich Hospital perhaps owes a greater (though indirect) debt to Bernini's colonnade.

above
Carlo Maderna,
S. Susanna, Rome,
1596–1603.

above right
Francesco Borromini,
S. Agnese in Piazza
Navona, Rome, exterior
1653–7.

ROMAN CHURCH FAÇADES

St Peter's and Versailles presented rare challenges and opportunities. Nearly all the new Roman churches and most of the older ones that were remodelled were quite small. Usually they had to be fitted into cramped sites between other buildings so that, externally, all attention had to be focussed on the façade. Already, in 1575, the new Jesuit church, the Gesù, had been given a façade that served as the starting point for later designs. Maderna's most successful façade – that of the church of S. Susanna – was closely modelled on it, but more unified, more vigorous, and with more vertical emphasis. As later at the Louvre, the main elements are classical columns, entablatures, and pediments. But they are arranged in two storeys in a wholly unclassical way. In the main body of the façade, columns in the lower storey give way to flat pilasters in the upper one, though smaller columns are enclosed within the innermost upper pilasters. In both storeys there is the same change in rhythm towards the centre. And the outermost bay of the lower storey ends in a flat pilaster that gives way, in the upper storey, to an S-shaped volute. Looking at this façade in detail we may well be reminded of a Rubens landscape. Here, horizontals and verticals, curves and diagonals, light and shade, small elements and grander embracing

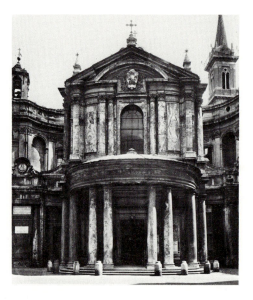

Pietro da Cortona,
S. Maria della Pace,
Rome, exterior 1656–7.

ones, come together to direct our eyes to the entrance and to carry them upwards. Or we may prefer to think of them as sounding together in one great musical chord.

In comparison with the façades designed half a century later by Francesco Borromini, Pietro da Cortona, and Bernini, the façade of S. Susanna is, nevertheless, restrained. Borromini's façade to the church of S. Agnese in one of Rome's finest squares, Piazza Navona, is far from being just a flat wall enlivened by classical details and shallow projections and recessions. The slightly projecting main porch is set in the middle of a much deeper curved recession that gives full emphasis to the dome rising above it. The pairs of columns to each side of the central door carry the eye up from the porch to the dome, where they are echoed by paired pilasters between the recessed windows. Towers, rising in two storeys above the main façade, flank the dome and ingeniously change from a square to a circular plan in the second storey. Look carefully at the way in which Borromini has achieved this transition and thereby related the towers more closely to the dome. The details throughout also repay close attention, for much of the liveliness and sense of movement without loss of overall unity depend on them. Some details, like the frames of the side doors, would never have been found in a classical building.

The front of Cortona's S. Maria della Pace is even less of a flat façade. The porch comes forward in a great sweep into the street and the undulating and boldly detailed wall of the storey above it is

80

thrust forward by flanking wings that curve forward at the ends like embracing arms. This much is clear from the photograph. But only on the site does one realise quite how skilful the architect has been. For this is a remodelling of a much earlier church squeezed between narrow streets to left and right that meet one another in a tiny square in front of it. The flanking walls are really those of adjacent buildings and the opening immediately to the right of the porch is actually the entrance to one of the side streets. The strong contrasts of light and dark under the Italian sun and the strong in-and-out movements are now more reminiscent of Caravaggio's paintings. But we might also note that there are similarities with theatre and stage design at the time.

NEW WAYS OF SHAPING SPACE

The internal planning of the church of the Gesù also established a pattern that was widely followed, with variations, during the seventeenth century. The usual earlier plan for a church (alongside the Renaissance symmetrical plan centred on a dome as in Michelangelo's design for St Peter's) was the familiar one of a central nave flanked by one or more aisles on each side. The main altar was at the furthest end from the entrance, and the lay congregation were kept at some distance by a space in front of the altar reserved for the clergy. (Many Gothic cathedral interiors were like this.) If the church was full, many of the congregation, particularly in the aisles, had a poor view of what was happening at the altar. The Jesuits wished to give all the congregation the best possible view of the altar and pulpit. The nave of the Gesù was therefore made wider and the aisles were replaced by shallow chapels opening off it, to be used only for more private ceremonies and prayer. The visual focus from anywhere in the nave was the main altar. Attention was also directed towards the altar by placing a large dome a little in front of it and thus admitting a much stronger light than that in the nave.

Where this plan was not fairly closely followed, the trend was towards expanding the space under the dome to take most of the congregation and proportionately reducing the size of the nave or

above
Francesco Borromini,
S. Ivo della Sapienza,
Rome, 1642–50.

above right
Guarino Guarini,
S. Lorenzo, Turin,
1667–87.

eliminating it. S. Agnese in Piazza Navona is a straightforward
example of this trend. (The side towers are independent of the
church proper.) In a later church for the Jesuits, S. Andrea al
Quirinale, Bernini made the whole main body of the church an oval
whose longer axis was set across the axis from entrance to altar. Well
before either of these churches was built, Borromini had already
used a basically oval plan for the small church of S. Carlo alle Quattro
Fontane (1638–41). Here the longer axis was that leading to the
main altar. But both here and at the entrance and the centre of each
side the oval was opened out at ground level into a curved recess.
The walls therefore flow alternately in and out in a continuous
movement that is resolved only at a level well above the main cornice
into the simple smaller oval of the dome. At S. Ivo della Sapienza,
Borromini then carried a similar alternation of convexities and
concavities right up into the dome itself. This continuous move-
ment of the surfaces makes it difficult, when one is inside the church,
to appreciate exactly where the true boundaries of the space are.

The culmination of this trend is to be seen in Guarino Guarini's
church of S. Lorenzo in Turin. Guarini opens out the undulating
boundaries of the space at each level to let in more and more light as
they rise and close in towards the lantern at the top of the dome. By
purely architectural means he creates as strong an impression of the

82

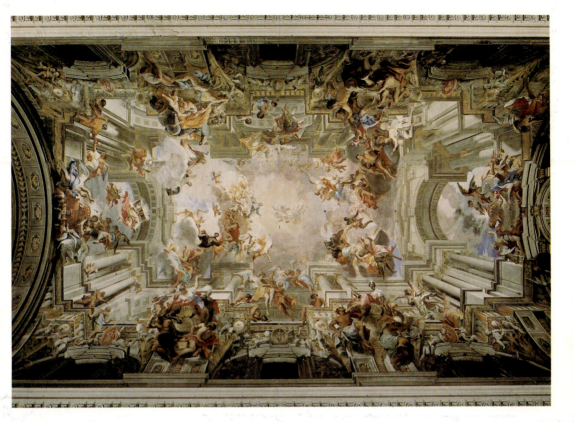

Andrea Pozzo, *Allegory of the missionary work of the Jesuits*, 1691–4, ceiling fresco, S. Ignazio, Rome.

space inside the church opening up to heaven as Bernini had created in the Cornaro Chapel (p. 10) with the help of illusionist painting.

REACHING FOR HEAVEN IN CEILING PAINTINGS

The desire to open up the space inside became very common, particularly in palace reception rooms and churches, as the century progressed. For practical reasons, Bernini's alternative of illusionist painting was usually the only feasible one in a palace. It was also the only possible one in an existing church like the Gesù, or in any other church closely modelled on it with similar vaults and dome. We have already seen one early example in Annibale Carracci's ceiling in the Palazzo Farnese.

The most spectacular painting of this kind was Andrea Pozzo's allegory of the missionary work of the Jesuits in the church dedicated to St Ignatius himself. This covers the whole ceiling of the nave and shows the real walls of the nave as extended far up into the

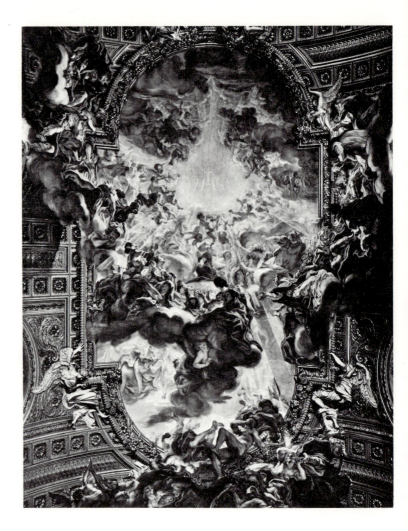

Giovanni Battista Gaulli, *The Triumph of the Name of Jesus*, 1674–9, ceiling fresco, Gesù, Rome.

sky by clustered columns bearing entablatures and arches. Figures fly about in the sky and among the columns. The whole ceiling is a tour de force of architectural perspective. Indeed Pozzo illustrated it in detail in a book on perspective that he wrote at the time. But it falls short of being the perfect marriage of painting and architecture because the illusion only works when one stands centrally beneath it in the position of the camera.

Bernini had already shown how this marriage could be achieved in the Cornaro Chapel. Painting should be restricted to the heavenly apparitions. Clearly defined forms that easily give the lie to the illusion if they appear distorted should be truly represented in three dimensions by sculpture or stucco relief if they are not part of the real architecture. Lighting should also be carefully considered in

relation to what is portrayed – a requirement often forgotten in modern artificial lighting of these interiors.

The finest realisation of Bernini's ideas was that of an earlier pupil and assistant, Giovanni Battista Gaulli, in the church of the Gesù. This scheme of decoration was not executed until a hundred years after the church was built and is typical of what is sometimes called the High Baroque rather than of the missionary phase of the Counter Reformation to which the church itself belongs. The whole scheme embraced the vault above the altar and the dome, but culminated in a representation of the Triumph of the Name of Jesus in the vault of the nave. The architectural frame is now all executed in stucco on the real vault surface. Painted clouds in shallow relief and figures sculpted in the round spill out over it to lead the eye into the vision painted in the centre. Here the name of Jesus – IHS – appears in shining glory scattering all heresies and wickedness to outer darkness.

BAROQUE ARCHITECTURE OUTSIDE ITALY

To turn from this to the chief French example of church architecture – the Invalides in Paris – is to be confronted again with the relative severity of French classical restraint. But we see again the use of paired columns in both storeys of the front and in the drum. There are similar projections and changes in rhythm to those seen in Roman façades. And the projecting pairs of columns in the drum are linked to the external ribs of the dome by volutes like those in the façade of S. Susanna. For all its strict discipline, the assertive squareness of the ground plan, and the emphatic vertical emphasis, it is a very lively and unified design. The interior is more typically Baroque, particularly the dome. One looks up and sees, through a large open eye in an inner shell level with the upper tier of windows, a painted upper shell brightly lit by the concealed light from these windows.

Almost contemporary with the church of the Invalides is Wren's St Paul's in London. The two are indirectly related because Wren visited Paris when he was first considering the design for St Paul's. He also met Bernini there and would have heard something of the

right
J. H. Mansart, Invalides,
Paris, 1680–91.

below
Christopher Wren,
St Paul's, London,
1675–1710.

discussions between Bernini and Louis XIV's architects about the design of the Louvre.

St Paul's was a long time in building – though not as long as St Peter's, to which it is also clearly related. Partly for this reason, and partly because Wren was far from having a free hand to plan as he wished, the design is certainly less unified. It is probably most successful in the two transept fronts above which the dome rises majestically as a perfect crown. The impressive colonnaded drum is echoed by the ground-level porch derived from that of S. Maria della Pace. The west front combines flanking towers with a pedimented porch as does the façade of S. Agnese in Piazza Navona. But the proportions are quite different. The two-storeyed porch is much more like that of the Invalides. And the towers become detached only above the level of the porch instead of being prepared for by recessions and projections of the whole façade. If we can say that French architecture, like French painting, displays passion checked by reason, we should perhaps say that Wren's St Paul's despite its similarities, displays reason held in check by committee. Whether we like it or not, Baroque architecture came into its own in the service of single-minded despots, whether secular rulers or princes of the Church.

Its final flowering takes us beyond the strict limits of this book – into the early eighteenth century – so that we can look at it only very briefly. Up to the middle of the seventeenth century, central Europe had been ravished and impoverished by the Thirty Years War. Only towards the end of the century had there been sufficient recovery for major building projects to be undertaken. The peace treaties had established a large number of independent minor despots (including princes of the Church) who then vied with one another to rebuild churches, monasteries, and palaces. While countries like France and Italy in which the Baroque style had previously developed or taken root were turning to a new classicism or to a surface decoration that largely ignored the underlying architecture, these patrons now adopted it enthusiastically. The richness and the immediacy of the impact that the Baroque style makes must also have had a considerable appeal to the Catholic peasants of what were still very largely agricultural communities.

The churches usually kept to the type of plan adopted more than a

hundred years previously for the Gesù in Rome. But this was reinterpreted in terms of the continuous movement of surface and spatial ambiguities introduced by Borromini and Guarini, and the effect was heightened by means of ceiling paintings and stucco decoration like those of S. Ignazio and the Gesù. A similar richness of decoration, and sometimes also of surface, was introduced into palace architecture. The Zwinger at Dresden shows it well. Note how, in the gate pavilion, convexities on one face give way to concavities on the other; pediments are broken and face first outwards and then inwards; and the whole upward surge is marvellously terminated in a fantastic squashed crown-like cupola. If it is possible to out-Borromini Borromini, Poppelmann did so here. The achievement is the more remarkable because there is no loss of control and the underlying architectural structure remains clear. When that structure disappeared behind a riot of stucco decoration, Baroque had given way to the style known as Rococo.

Notes on artists

ALGARDI, ALESSANDRO, born Bologna 1595, settled in Rome 1625. He worked chiefly as a sculptor in a more classical style than Bernini. Died 1654.

BERNINI, GIANLORENZO, born Naples 1598, the son of a sculptor; taken to Rome as a boy, 1605. There he attracted the attention of the pope's nephew, Cardinal Scipione Borghese, for whom he made several mythological sculptures such as *Pluto and Persephone* and *David*. Brilliant, witty, capable of rapidly executing complex designs and of carving marble almost as if it was clay under his hands, he was already a famous portrait sculptor by the 1620s. Having begun work on the baldacchino in St Peter's in 1624, he was appointed architect to the church in 1629. By then he was leaving minor works mainly to assistants and concentrating on major monumental and religious works, mostly in Rome. He worked for Popes Urban VIII, Innocent X, and Alexander VII. Louis XIV invited him to France 1665. Died 1680.

BORROMINI, FRANCESCO, born Bissone on Lake Lugano 1599, the son of a mason; moved to Rome in his early twenties where he initially found work as a stone carver under Maderna and subsequently Bernini. He also assisted Bernini with designs, but Bernini's greater success and the very different characters of the two men led to their parting and becoming rivals. Most of Borromini's own works were relatively small churches, but of great originality and importance. Committed suicide 1667.

BOSSCHAERT, AMBROSIUS, born Antwerp 1573; moved to Middelburg. A painter who specialised in fruit and flowers. Died 1612.

BRUEGEL, JAN, born 1568, the son of a more famous painter father. Specialised in detailed flower paintings and landscapes. Died 1625.

CARAVAGGIO, MICHELANGELO MERISI DA, born Caravaggio near Bergamo 1573; went to Rome c. 1590 after early apprenticeship in Milan. In late 1590s received major commissions for religious paintings through Cardinal del Monte and subsequently special-ised in large religious works. These were often criticised for their uncompromising realism in portraying saints as ordinary people, and sometimes rejected by the churches for which they were painted only to be bought by Cardinals or nobles who recognised their sincerity and essential truthfulness. Forced to leave Rome as a result of his quarrelsome behaviour, he fled to Naples and then Malta. Died on his way back to Rome 1610.

CARRACCI, AGOSTINO, born Bologna 1557. Worked as both painter and engraver in Bologna (with his brother Annibale and cousin Ludovico), Venice, Parma, and (with Annibale again) Rome. Died in Parma in 1602.

CARRACCI, ANNIBALE, born Bologna 1560. The youngest but greatest of the Carracci, he also worked in Bologna and visited Venice before going to Rome to work for Cardinal Farnese on the decoration of his palace. With his brother he revitalised the mainstream of Italian painting in central Italy by looking back to the work of Raphael and Michelangelo. Died in Rome 1609.

CLAUDE GELLÉE, (also called Claude Lorraine), born near Nancy 1600; went to Italy c. 1613; in Rome from 1620 apart from a brief return to Nancy 1625. By the late 1630s he had earned a great reputation as a painter of poetic classical landscapes based on keen observation of the countryside around Rome which he recorded in very free sketches. These landscapes are peopled with figures from classical or biblical stories, but always seen from a distance so that the landscape, extending always to a far horizon, becomes the main subject. Died 1682.

CORTONA, PIETRO DA, born Cortona 1596, the son of a mason; went to Rome c. 1612. Initially worked mostly as a painter on large decorative schemes in palaces and churches, especially for Pope Urban VIII and the Barberini family. Later he turned also to architecture and became equally notable for his designs for a number of Roman churches, though he probably always regarded himself as primarily a painter. Died 1669.

DYCK, ANTHONY VAN, born Antwerp 1599, where he became Rubens's chief assistant while still in his teens.

First visited England 1620; travelled in Italy 1621–5; finally settled in England 1632 where he was knighted by Charles I and became a prolific portrait painter. His style owed much to Rubens. Died 1641.

GIRARDON, FRANÇOIS, born 1628; visited Rome *c.* 1645–50. Subsequently worked as a sculptor for the French court, chiefly at Versailles. Died 1715.

GOYEN, JAN VAN, born Leyden 1596; visited France as a young man and travelled around Flanders and Holland but based in The Hague after 1634. He was a prosperous landscape painter but prone to financial speculations. Died insolvent on this account in 1656.

GUARINI, GUARINO, born Modena 1624; became a Theatine priest, a philosopher, and a mathematician before turning also to architecture. He was in Rome 1639–47, where he came to know the churches designed by Borromini; in Modena again 1647–55; in Messina 1660–62; in Paris 1662–4; and finally settled in Turin, though he may also have visited Spain and Portugal since he designed a church in Lisbon. His architecture, as well as showing the influence of Borromini, shows his mastery, as a mathematician, of three-dimensional geometry, and suggests that he also had considerable knowledge of Central European High Gothic vaults and spires – either directly or, perhaps, through acquaintance with some of Leonardo's architectural sketches and projects. He wrote a book about his buildings and his architectural ideas, but this was published only after his death. Died 1683.

HALS, FRANS, born Antwerp 1581/5; probably moved to Haarlem with his parents *c.* 1585 when Antwerp fell to the Spaniards. After apprenticeship worked in Haarlem as a portrait painter, but his earlier prosperity declined during the 1640s. Died destitute in 1666.

HEEM, JAN DAVIDSZ. DE, born Utrecht 1606; worked there and in Leyden before moving to Antwerp 1636. A painter of still-life, especially flowers and fruit, with a large following. Died 1683/4.

HONTHORST, GERARD VAN, born Utrecht 1590; in Rome *c.* 1610–20 where he was influenced by the paintings of Caravaggio; subsequently returned to Utrecht. He adopted Caravaggio's manner of making figures emerge from a dark background by means of directed light, but preferred a single candle as the source rather than daylight. Died 1656.

HOOGH, PIETER DE, born 1629; worked mainly in Delft as a painter of genre interiors until moving to

Amsterdam in 1667 when his work became more pretentious but deteriorated in quality. Died 1684 or later.

LEBRUN, CHARLES, born 1619; in Rome 1642–6, when he returned to Paris. He was primarily a painter but, as Director of the French Academy of Painting and Sculpture, he became, under Louis XIV, the effective dictator of all the arts in France. Died 1690.

MADERNA, CARLO, born 1556 at Capolago on Lake Lugano; settled in Rome by 1588 as assistant to his uncle Domenico Fontana; while finishing the façade of S. Susanna, 1603, he was also made architect of St Peter's where he added a nave and façade (1607–12) to Michelangelo's plan. His work included the Mattei Palace (1598–1618) and designs for the Barberini Palace, which was almost entirely executed after his death by Bernini. Died 1629.

POUSSIN, NICOLAS, born in Normandy 1594; went to Paris *c.* 1612 and to Rome 1624; remained there (apart from a short and unsuccessful return to France in 1640–42 to work for Louis XIII and Cardinal Richelieu) for the remainder of his life. He was greatly influenced by classical antiquity as well as by painters like Titian and, later, Raphael. His style gradually changed from a colourful lively Titianesque one to a less colourful one in which nothing was allowed to detract from the nobility and serious moral import of the human action portrayed – whether biblical or from classical mythology. Landscape or architectural backgrounds were carefully planned to enhance the action and to contain it, rather than leading the eye to infinity as do Claude's landscapes. Poussin planned his pictures with great care, even using a miniature stage on which he arranged wax figures suitably clothed. By working in this way he could more readily achieve the ideal he sought than if he was distracted by the accidents and sensuous attractions of real life. Died 1665.

POZZO, ANDREA, born 1642; became a Jesuit lay brother 1665, but was persuaded to continue painting; in Rome 1681–1702 then left for Vienna. He specialised in illusionist ceiling paintings displaying a great skill in architectural perspective. Died 1709.

REMBRANDT VAN RYN, born Leyden 1606, the son of a miller. After a year at Leyden University he was apprenticed to a local painter and then, 1624, to a more important painter in Amsterdam. He returned to Leyden, 1625, but settled finally in Amsterdam *c.* 1631, where he married Saskia van Uylenborch whose wealthy family connections were the foundation of his pros-

perity, chiefly as a fashionable portrait painter, up to her death in 1642. After this his business declined and his lavish spending led to bankruptcy in 1656. There was, however, no decline in his artistic powers. He turned increasingly to biblical subjects, to landscapes, and to portraits of the ordinary, mostly Jewish, people among whom he now lived, as well as continuing to paint himself. As well as painting, he made many superb drawings and etchings. His work was characterised by a use of light derived ultimately from Caravaggio and by an unequalled depth of human sympathy and understanding. His output was enormous and for many years he also had numerous pupils. Died 1669.

RENI, GUIDO, born 1575; worked in Rome and, mainly, in Bologna. His style was most influenced by the Carracci. Died 1642.

RUBENS, PETER PAUL, born Siegen, Westphalia 1577; returned to the parental home town of Antwerp 1589 and trained there as a painter *c.* 1592–9. He was in Italy as court painter to the Duke of Mantua 1600–08, during which time he visited Spain as well as travelling in Italy studying and copying the work of other artists, notably that of Titian. He went back to Antwerp on the news that his mother was dying and remained there as court painter to the Spanish regents apart from trips abroad (to Holland 1627, Spain 1628, and England 1629) as their envoy – for he was also widely educated and possessed considerable diplomatic skill. His output was vast in both range and quantity and it included many large-scale works. Like Bernini he had the ability to direct numerous skilful assistants. They did much of the actual painting on the basis of sketches which he himself drew with the brush in a very free and lively style. His prosperity lasted throughout his career. He built himself a palatial house in Antwerp, later acquired also the Castle of Steen, and was knighted by Charles I of England. Died 1640.

SAENREDAM, PIETER JANSZ., born near Haarlem 1597; studied in Haarlem 1612–22 and worked there as a painter of architecture, especially church interiors, from *c.* 1628. His paintings were based on very careful thought and lengthy preparation starting with sketches made on the spot and proceeding to accurate perspective drawings made from measured plans and elevations. This gives them something of the quality of photographs taken, face on to one of the principal axes of the building, with a wide-angle lens and a rising front – except that no photograph can select and reveal through light in quite the same way. Died 1665.

TERBRUGGHEN, HENDRICK, born Deventer 1588; after apprenticeship as a painter visited Italy 1604–14. He was influenced by Caravaggio's realism, though less than other painters by his use of light. Terbrugghen preferred an ampler softer light more like that of northern daylight. But, like Caravaggio's, his paintings are mostly figure compositions with the figures filling much of the canvas. Died 1629.

VELAZQUEZ, DIEGO RODRIGUEZ DE SILVA, born Seville 1599; after training in Seville worked there for a short time before becoming court painter in Madrid 1623. Through Rubens he obtained permission to visit Italy 1629–31 and he made a second visit 1648–51 accompanying a royal embassy. His paintings are mostly portraits or portrait groups with a few religious and historical and other works. They have a soft atmospheric realism of their own, unrelated to that of Caravaggio and, though sometimes sombre in colour, could also be very rich. Died 1660.

VERMEER, JAN, born Delft 1632. He practised as a painter from *c.* 1653, but very little is known about his life or even the dates of most of his paintings, save that he seems to have been a slow and retiring worker, sometimes unwilling to part with what he had done, and usually short of money despite his also taking over an inn on his father's death and probably doing some art dealing. Only about forty canvases remain and their high merit has been recognised again only fairly recently. They mostly reflect the quiet enjoyment of life in the home typical of mid-century Holland and have what has been described as 'the charm and simplicity of a flower'. But this simplicity is the result of great pains in selecting and composing the subject and superb skill in the choice of colour and the handling of the brush. Died heavily in debt 1675.

WITTE, EMANUEL DE, born Alkmaar 1616/18; probably studied in Delft and active there *c.* 1641–51; spent the rest of his life in Amsterdam. He was a versatile painter who turned to architectural subjects only *c.* 1650. Usually these paintings lacked the faithful accuracy of Saenredam's; they tended to be rearrangements, for pictorial purposes, of real interiors, or even quite fanciful. There is, for instance, no known interior quite like his 1668 painting. Committed suicide 1692.

WREN, CHRISTOPHER, born 1632, son of the Dean of Windsor and nephew of the Bishop of Ely; received a good general education at Westminster School and Oxford and became Professor of Astronomy in London 1657 and in Oxford 1661. He turned to architecture

only when appointed to a commission for the restoration of St Paul's Cathedral. This led to a visit to Paris to study French architecture 1665–6. After the Great Fire of London he became Surveyor, and then Surveyor General, of the King's Works and resigned his professorship. He was knighted 1673. His major work was the rebuilding of St Paul's, but he was also responsible for about fifty new city churches 1670–86, and for many other buildings from the Sheldonian Theatre, Oxford 1663 to Greenwich Hospital 1694 onwards. Though he met Bernini in Paris, the chief influence on his work was probably what he learnt there from Mansart and Le Vau and what he learnt from his extensive library of illustrated Italian architectural books. Died 1723.

Further reading

Three books that will give a broader view of the whole history of art and of its background are:
 E. H. Gombrich, *The story of art*, Phaidon, 1954 and numerous later editions
 Kenneth Clark, *Civilisation*, BBC and John Murray, 1969
 H. W. Janson, *History of art*, 1974, Prentice-Hall/Abrams

The best books on major seventeenth-century artists for the non-specialist are:
 Howard Hibbert, *Bernini*, Penguin, 1965
 Kenneth Clark, *An introduction to Rembrandt*, John Murray, 1978

For more detail discussion of the work of other artists (and architects) and for general reference the most useful books are the appropriate volumes of the Pelican History of Art. Those on Italy and Holland are the most important for the period and are both very readable even though, at first sight, they may appear rather formidable:
 Rudolf Wittkower, *Art and architecture in Italy 1600 to 1750*, Penguin, 1958
 Jakob Rosenberg, Seymour Slive, and E. H. Ter Kuile, *Dutch art and architecture 1600 to 1800*, Penguin, 1966
Other volumes are:
 E. Gerson and E. H. Ter Kuile, *Art and architecture in Belgium 1600 to 1800*, Penguin, 1960
 Anthony Blunt, *Art and architecture in France 1500 to 1700*, Penguin, 1953
 John Summerson, *Architecture in Britain 1530 to 1830*, Penguin, 1953
For the final phase of Baroque architecture in central Europe see:
 Eberhard Hempel, *Baroque art and architecture in central Europe*, Penguin, 1965

Glossary

ACANTHUS a plant with deeply serrated prickly leaves.

ALLEGORICAL representing something indirectly by means of a story, emblem, or imaginary figure.

AISLE part of a rectangular church or other building to one side of the central space, or nave, and separated from it by a colonnade or similar means.

APSE a semicircular or many-sided recess, particularly that behind or containing the main altar of a church.

ARCHITRAVE the lowest member of an entablature – the beam that spans the tops of adjacent columns.

ASSUMPTION taking up bodily into heaven, especially of the Virgin Mary.

BALDACCHINO a canopy or crown supported on columns, especially over an altar.

BALUSTRADE a row of short posts supporting a horizontal rail.

BAROQUE a term referring to the arts (including architecture) of the seventeenth century and (chiefly in central Europe) a little later. Also used to refer to the stylistic character most typical of this period.

BASE the foot of a column, wall, etc.

BASILICA in ancient Rome, a large meeting hall, usually rectangular; in Early Christian times, a church, since the early church adopted essentially the earlier meeting-hall type of building for most new structures; hence used still to refer to the original churches of early Christian Rome and elsewhere.

CAPITAL the head or crowning feature of a column or pilaster.

CHIAROSCURO the balance of alternating light and dark in a picture, especially when this is an important means of achieving an effect.

CHOIR the part of a church, around the high altar, which is reserved for the clergy and choir for the singing of services.

CLASSICAL a term referring to the arts (including architecture) and to other products and legacies of ancient Greece from the sixth century BC onwards and of ancient Rome from about the second century BC onwards, and to work of later date that has a very similar character. The term is sometimes used more restrictively to refer only to what is regarded as the best work of these periods – work having a particular order, balance, and harmony. Hence it is used also of these qualities of order, balance, and harmony in art of other times.

CLASSICISM a tendency towards the use of classical forms.

COLONNADE a row of regularly spaced columns.

COMPOSITE in architecture, the fifth classical order; a blend of ionic and corinthian.

CORINTHIAN the fourth classical order; columns are deeply fluted and have capitals shaped as inverted bells with acanthus leaf decoration.

CORNICE a horizontal projection, usually ornamented, along the top of a wall or forming the uppermost part of an entablature.

CROSSING the space at the intersection of nave, choir, and transepts, in a church of cross-shaped plan.

CUPID the Roman god of love, usually represented as a winged boy with bow and arrows.

CUPOLA a small dome.

DOME a continuously curved vaulted roof, circular in plan.

DORIC the first classical order; columns are broader than in other orders, have broad shallow flutes, no base, and saucer-shaped capitals.

DRUM a cylindrical wall, often perforated with windows, supporting a dome.

DYNAMIC active, forceful, in movement, or suggestive of movement.

ENTABLATURE the complete set of horizontal members resting on top of a column and running continuously above a colonnade; usually consists of architrave, frieze, and cornice.

ETCHING a method of printing on paper, or a print so made, described in chapter 3.

FAÇADE the principal face of a building, usually towards a street or open space and containing the main entrance.

FIGURES representations of people.

FLUTES concave grooves running vertically up the surface of a column.

FORMS shapes, often three-dimensional, of which a work of art is composed.

FRIEZE the middle part of an entablature, often decorated.

GENRE a type of painting representing a scene from everyday life in everyday surroundings; usually fairly intimate and small-scale.

ICONOCLASM the destruction of images, especially of religious pictures and sculpture in churches.

IONIC the third classical order; columns stand on a moulded base, are deeply fluted, and have capitals decorated with a pair of volutes.

LANTERN an open construction on top of a dome, usually with a drum surmounted by a cupola and designed to admit light to the space under the dome.

MAENAD a female follower of Bacchus, the god of wine.

MASQUE a musical pageant.

MYTH a traditional ancient story of gods and heroes.

NAVE the central part of a rectangular church or other building, where the parts to each side are separated off as aisles; in a church where the end containing the main altar is separated off by a screen or transept, that part between the main entrance and this screen or transept.

NICHE small recess in wall.

OBELISK tall slender tapering shaft of stone, usually granite; a form common in Egyptian architecture, many obelisks now in European capitals having been brought from Egypt.

ORDER in classical architecture, a column together with its base (if any) and capital, and including also the entablature; the five principal orders follow clearly defined traditional patterns as described elsewhere – i.e. doric, tuscan, ionic, corinthian, and composite.

PEDIMENT in classical architecture, the low-pitched triangular feature above the entablature at the ends of a temple; in later architecture a similar feature may be used over porches, doors, and windows, may have a curved top, and may even have a broken outline.

PERSPECTIVE the art of representing solid objects or other shapes at different distances from the observer by means of lines on a flat surface, so as to create an impression of volume, distance, and spatial relations; sometimes used also of the modification of colours in painting to give the effect of increasing distance.

PIAZZA the Italian name for a square or similar open space surrounded by buildings.

PILASTER a shallow flat projection from a wall resembling a column partly embedded in the wall.

PLINTH a projecting base, usually square-faced.

PORTICO a roofed entrance to a temple, church, or other building; often projecting from the main façade and resembling the front of a classical temple.

RENAISSANCE a period of European, and particularly Italian, history in which a new interest was taken in the classical past and its arts and an attempt was made to emulate these. In Italy this period began about 1400 and lasted until some time (variously defined) in the sixteenth century. Elsewhere it began and ended rather later and is less sharply distinguishable from the preceding and following periods. Also used as a term to denote the arts (including architecture) of this period.

RESURRECTION rising from the dead.

ROCOCO a style, particularly in early eighteenth-century France and a little later in central Europe, that followed the Baroque. It is basically a style of interior decoration, but a similar light-hearted gaiety and use of continuously flowing curves may also be found in the work of some painters.

SACRISTY a room attached to a church and intended (at least in origin) for the keeping of ceremonial robes (vestments), sacred vessels for use in services, etc.

SATYR a god of the woods with bearded face and horns and the legs and tail of a goat.

STILL-LIFE a type of picture representing inanimate objects such as fruit, flowers, kitchen utensils, musical instruments.

STUCCO plasterwork.

TONE relative lightness and darkness of the colours used in painting.

TRANSEPT a projection to one side of the main body (nave and choir) of a church of cross-shaped plan.

TUSCAN the second classical order, a simpler form of doric without flutes on the columns but with column bases.

VAULT an arched roof or ceiling which may have a simple form like that of half a barrel or may be composed of two or more such forms or have an even more complex curved form with or without projecting ribs.

VOLUTE a scroll-like element, found in the ionic capital and in later architecture as a variation of an essentially triangular section of wall on a façade or against some higher part of the building.

Index

Page references of illustrations are indicated by bold type

Algardi, Alessandro, tomb of Leo XI 15, **16**
Allegory of the Missionary Work of the Jesuits (Pozzo) 83, 84
Amsterdam 27
Antwerp 35, 53
Apollo Belvedere 8, **9**
Assumption of the Virgin: (Agostino Carraci) 6, **7**; (Titian) 6, **7**

Bacchanalian Revel before a Herm of Pan (Poussin) 46
Baroque art and architecture 1, 5–12, 20, 47
Belgium *see* Flanders
Bernini, Gianlorenzo 9, 13, 17, 44: *David* 8, **9**; *Ecstasy of St Theresa* **frontispiece**, 9–12; *Goat Amalthea with the Infant Jupiter and a Faun* **13**; *Louis XIV* **17**; Louvre, Paris 77; *Neptune and Triton* 14, **15**; *Pluto and Persephone* 14, **15**, 22; St Peter's, Rome (baldachino) 18–20, **19**, (chair of St Peter) **19**, 20, (colonnade) 76, **77**; S. Andrea al Quirinale, Rome 82; *Thomas Baker* **17**; tomb of Urban VIII 15, **16**
Borghese, Cardinal Scipione 14
Borromini, Francesco: S. Agnese in Piazza Navona, Rome 79, 80, 87; S. Carlo alle Quattro Fontane, Rome 82; S. Ivo della Sapienza, Rome 82
Bosschaert, Ambrosius, *Bouquet in an Arched Window* 41
Breughel, Jan I (and Rubens), *Virgin and Child in a Flower Garland* 40, 41
Burial of Phocion (Poussin) 69

Calling of St Matthew: (Caravaggio) 22–4, **23**; (Terbrugghen) 26
Caravaggio, Michelangelo Merisi da 21, 24, 27, 31: *Calling of St Matthew* 22–4, **23**; *Death of the Virgin* 33, **34**; *Supper at Emmaus* 21, 22

Cardinal Richelieu (Champaigne) 55
Card Players (Hoogh) **74**
Carraci, Agostino, *Assumption of the Virgin* 6, **7**
Carraci, Annibale: *Domine, quo Vadis?* 43–5, **44**; Palazzo Farnese, Rome, ceiling fresco 3–6, **4**, **5**, **12**
Champaigne, Philippe de, *Cardinal Richelieu* 55
Christ at Emmaus (Rembrandt) **30**, **31**; *see also Supper at Emmaus*
Christ before the High Priest (Honthorst) **25**, 26
classical art and architecture 8, 21, 43, 46, 77–8
Claude Lorraine, *Landscape with the Marriage of Isaac and Rebecca* 69, 70–1
Cornaro Chapel (Bernini) 9–12, **10**, 84–5
Cornelis Claesz Anslo (Rembrandt) 59–61, **60**
Cortona, Pietro da, S. Maria della Pace, Rome 80, 81, 87

David: (Bernini) 8, **9**; (Michelangelo) 8, **9**
Death of the Virgin (Caravaggio) 33, **34**
Descent from the Cross (Rubens) **36**, 37
Dientzenhofer, Georg, St Nicholas on the Lesser Side, Prague 88
Domine, quo Vadis? (Carraci) 43–5, **44**
Dyck, Anthony van 53–4: *Maria de Raet* **53**; *Queen Henrietta Maria with her Dwarf* **53**, 54

Ecstasy of St Theresa (Bernini) **frontispiece**, 9–12

Farnese, Cardinal Oduardo 3, 5
Finelli, Guiliano, *Francesco Bracciolini* **17**
Flanders 25, 33, 35
Flower Still Life (Heem) 41, **42**
France 55, 77
Francesco Bracciolini (Finelli) **17**

Galerie des Glaces *see* Versailles
Garden of Love (Rubens) **38**
Gaulli, Giovanni Battista,

Triumph of the Name of Jesus 84, **85**
Gesù, Rome 79, 81, 84
Girardon, Francois, *Pluto and Persephone* **15**
Goat Amalthea with the Infant Jupiter and a Faun (Bernini) **13**
Goyen, Jan van, *View of Leiden* **67**, 68
Greenwich Hospital (Wren) 78
Guarini, Guarino, S. Lorenzo, Turin 82, **83**

Hals, Frans, *Officers of the Civic Guard of St Adrian at Haarlem* 56–7, **58**
Heem, Jan Davidsz. de, *Flower Still Life* 41, **42**
Holland 25, 27, 35, 56, 58, 65
Holy Family on the Steps (Poussin) 46, **47**
Honthorst, Gerard van, *Christ before the High Priest* **25**, 26
Hoogh, Pieter de, *Card Players* **74**
Hundred Guilder Print (Rembrandt) 27–9, **28**, 37

Interior of a Church (Witte) **73**
Interior of St Bavo Church, Haarlem (Saenredam) **72**, 73
Invalides, Paris (Mansart) **85**, 86

Jesuits 2, 37, 81
Jewish Bride (Rembrandt) 61, **62**
Judgement of Paris (Rubens) **39**, 40

Landscape with the Marriage of Isaac and Rebecca (Claude Lorraine) 69, 70–1
Landscape with a Rainbow (Rubens) 66, **67**
Last Judgement, detail of Christ (Michelangelo) **2**, 8
Lebrun, Charles 47–9: Galerie des Glaces, Versailles **49**; Louvre, Paris 77; *Triumph of Alexander the Great* 49, **50**
Le Nostre, André, Versailles 78
Leo XI, tomb of (Algardi) 15, **16**
Le Vau, Louis: Louvre, Paris 77; Versailles 78
Louis XIV, of France 48, 75
Louis XIV: (Bernini) **17**; (Rigaud) 55
Louvre, Paris (Lebrun, Le Vau and Perrault) 77

Low Countries *see* Flanders *and* Holland

Maderna, Carlo: S. Susanna, Rome 79; St Peter's, Rome 76
Mansart, Jules Hardouin: Galerie des Glaces, Versailles 49; Invalides, Paris 85, 86; Versailles 78
Marchesa Brigida Spinola Doria (Rubens) 51, 52–3
Maria de Raet (Dyck) 53
Marriage Feast of Cupid and Psyche (Raphael) 3, 4, 6
Meninas, Las (Velazquez) 63, 64
Michelangelo Buonarroti: *David* 8, 9; *Last Judgement* 2, 8; S. Lorenzo, Florence, New Sacristy 11; St Peter's, Rome 18, 75–6

Neptune and Triton (Bernini) 14, 15
Night Watch (Rembrandt) 57–8, 59

Officers of the Civic Guard of St Adrian at Haarlem (Hals) 56–7, 58

Palazzo Farnese, Rome, ceiling fresco (Carracci) 3–6, 4, 5, 12
Paul III, Pope 2
Paul V, Pope 18
Perrault, Claude, Louvre, Paris 77
Pluto and Persephone: (Bernini) 14, 15, 22; (Girardon) 15
Poppelmann, Mathaes Daniel, Zwinger, Dresden 88
Poussin, Nicolas 46–7: *Bacchanalian Revel before a Herm of Pan* 46; *Burial of Phocion* 69; *Holy Family on the Steps* 46, 47
Pozzo, Andrea, *Allegory of the Missionary Work of the Jesuits* 83, 84

Queen Henrietta Maria with her Dwarf (Dyck) 53, 54

Raising of the Cross (Rubens) 36, 37
Raphael, *Marriage Feast of Cupid and Psyche* 3, 4, 6

Rembrandt van Ryn 26–7, 31, 62, 65–6: *Christ at Emmaus* 30, 31; *Cornelis Claesz Anslo* 59–61, 60; *Hundred Guilder Print* 27–9, 28, 37; *Jewish Bride* 61, 62; *Night Watch* 57–8, 59; *Return of the Prodigal Son* 31, 32; *Self Portrait* 62, 63; *Woman taken in Adultery* 29, 30
Renaissance art and architecture 1, 3, 11–12, 52
Reni, Guido, *Salome* 45
Return of the Prodigal Son (Rembrandt) 31, 32
Rigaud, Hyacinthe, *Louis XIV* 55
Rococo art and architecture 88
Rome 1–3, and passim
Rubens, Peter Paul 33–8, 65–6: *Descent from the Cross* 36, 37; *Garden of Love* 37, 38; *Judgement of Paris* 38, 39; *Landscape with a Rainbow* 66, 67; *Marchesa Brigida Spinola Doria* 51, 52–3; *Raising of the Cross* 36, 37; *Virgin and Child in a Flower Garland* 40, 41

Saenredam, Pieter Jansz., *Interior of St Bavo Church, Haarlem* 72, 73
St Francis Xavier 2
St Ignatius 2, 9
St Philip Neri 2, 24
St Theresa 2; *see also Ecstasy of St Theresa*
St Nicholas on the Lesser Side, Prague (Dientzenhofer) 88
St Paul's, London (Wren) 85–7, 86
St Peter's, Rome 2, 18–20, 75–7: baldachino (Bernini) 18–20, 19; chair of St Peter 19, 20; colonnade 76, 77
Salome (Reni) 45
S. Agnese in Piazza Navona, Rome (Borromini) 79, 80, 87
S. Andrea al Quirinale, Rome (Bernini) 82
S. Carlo alle Quattro Fontane, Rome (Borromini) 82
S. Ignazio, Rome 83, 84
S. Ivo della Sapienza, Rome 82
S. Lorenzo, Florence, New Sacristy (Michelangelo) 11
S. Lorenzo, Turin (Guarino

Guarini) 82, 83
S. Maria della Pace, Rome (Cortona) 80, 81, 87
S. Maria della Vittoria, Rome, Cornaro Chapel (Bernini) 9–12, 10, 84–5
S. Susanna, Rome (Maderna) 79
Sixtus V, Pope 2
Spain 63
Supper at Emmaus (Caravaggio) 21, 22; *see also Christ at Emmaus*

Terbrugghen, Hendrick, *Calling of St Matthew* 26
Thomas Baker (Bernini) 17
Titian, *Assumption of the Virgin* 6, 7
Trent, Council of 2
Triumph of Alexander the Great (Lebrun) 49, 50
Triumph of Bacchus and Ariadne (Carraci) 5, 6
Triumph of the Name of Jesus (Gaulli) 84, 85

Urban VIII, Pope 18: tomb of (Bernini) 15, 16

Velazquez, Diego, *Las Meninas* 63, 64
Venice 6, 33
Vermeer, Jan: *View of Delft* 70, 71–2; *Young Woman reading a Letter* 71, 72
Versailles (Le Vau, Mansart and Le Nostre) 78: Galerie des Glaces (Mansart and Lebrun) 49
View of Delft (Vermeer) 70, 71–2
View of Leiden (Goyen) 67, 68
Virgin and Child in a Flower Garland (Breughel and Rubens) 40, 41

Witte, Emanuel de, *Interior of a Church* 73
Wren, Christopher 85, 87: Greenwich Hospital 78; St Paul's, London 85–7, 86

Young Woman reading a letter (Vermeer) 71, 72

Zwinger, Dresden (Poppelmann) 88